SECRET PERTH

Gregor Stewart

AMBERLEY

First published 2024

Amberley Publishing
The Hill, Stroud
Gloucestershire, GL5 4EP

www.amberley-books.com

Copyright © Gregor Stewart, 2024

The right of Gregor Stewart to be identified as the
Author of this work has been asserted in accordance
with the Copyright, Designs and Patents Act 1988.

ISBN 978 1 3981 0838 7 (print)
ISBN 978 1 3981 0839 4 (ebook)

British Library Cataloguing in Publication Data.
A catalogue record for this book is available from the
British Library.

Origination by Amberley Publishing.
Printed in Great Britain.

Contents

Introduction

The land on which the city of Perth now stands has been occupied for centuries, with some historians theorising that a major settlement for the ancient Picts may have stood here prior to Scone and Abernethy becoming the main capitals. Nearby stone circles show that the area has been farmed and utilised for around 4,000 years, with archaeological findings suggesting that the land has been in use for over 8,000 years.

In the book *The Ancient Capital of Scotland Volume 1*, author Samuel Cowan suggests that excavations had previously revealed evidence of buildings dating back to the Roman era for a township known as Victoria. This is contrary to the more widely held belief that the Roman fort was north of the current city; however, as will be discussed in the next chapter, there is clear indications that the Romans were active here.

DID YOU KNOW?
Perth was originally known as St John's Toun after the church. The name lives on today with the football team named St Johnstone Football Club.

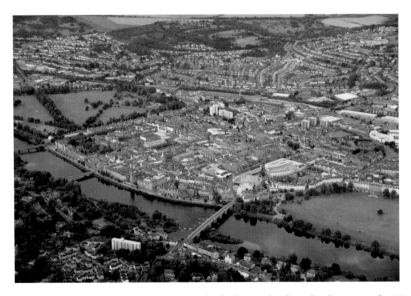

A general view over Perth city centre which shows the three bridges over the River Tay along with the North and South Inches. (Mike Pennington, CC BY-SA 2.0)

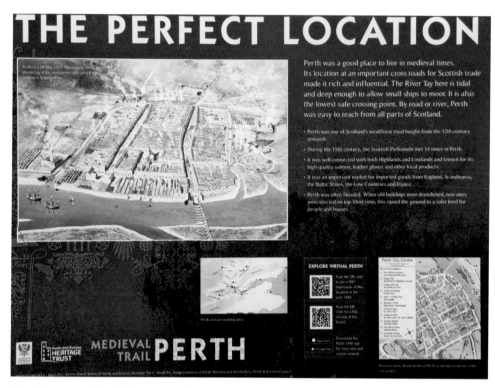

The information board that sits on the banks of the River Tay on Tay Street, opposite the junction with Canal Street. The board explains the importance of Perth.

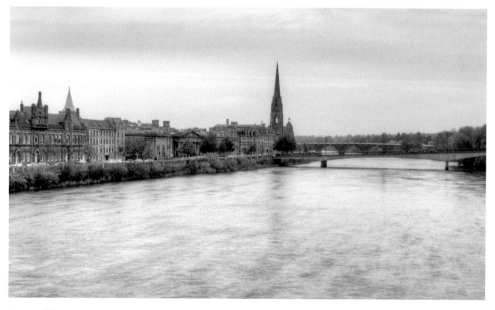

View of the River Tay showing the close proximity to the town centre buildings and the current bridges. (David Dixon, CC BY-SA 2.0)

The settlement continued to grow, although it was not until the twelfth century that Perth began to establish itself as a significant settlement when, in 1106, it was granted burgh status. This gave the merchants of Perth certain privileges to self-govern to an extent, with the centre of the burgh normally being the marketplace where traders could sell their goods and produce. In 1210, the town was granted royal burgh status, which was normally only granted to sea ports. It gave merchants the ability to trade abroad as well as wider administrative powers. By the sixteenth century, silting made the port almost unusable and Perth instead relied on other trades such as metal working, goldsmithing and leather working.

DID YOU KNOW?
The areas of parkland known as the North and the South Inch were gifted to Perth by King Robert II. Both were originally islands in the River Tay.

Perth had become a favoured place to stay by successive royal households, resulting in it serving as the capital of Scotland until the mid-fifteenth century. With such status, this, along with the military importance of being the first point at which the River Tay could be bridged (at that time), brought great benefits to the town yet also much destruction, with it being heavily fought over to control the river crossing.

The river also brought destruction, with a great flood in 1209 washing away the bridge and causing extensive damage. Later flooding caused further devastation to the town on several occasions. The plague decimated the population in the fourteenth century and again in the sixteenth century. In typical fashion, however, Perth adapted and recovered.

In the following chapters some of the most significant periods of history will be explored in more detail, along with a series of lesser-known interesting facts, all of which helped shape the city today.

DID YOU KNOW?
In 2001 a log boat was discovered having been buried in the mudflaps of the Carpow bank of the River Tay, which sits just a short distance from Perth. Radiocarbon dating revealed the boat, which is carved from a single oak log, to be around 3,000 years old, giving evidence that the lands were used as far back as the Bronze Age. It can now be viewed at the Perth Museum.

1. Roman Perth

The Roman armies first arrived in modern-day Great Britain in the year AD 43. After their initial landing in Kent, they swiftly marched north, seizing control of vast areas of the country. Far from seeking to destroy Britain, their aim was to conquer and take control of the country for its vast mineral and metal resources. As the Romans progressed in their invasion, they developed a significant infrastructure of roads and forts which allowed for easier and safer transportation of goods and supplies both into and out of the country. This also ensured that the front lines were kept well supplied and that reinforcements could be called upon from the forts at short notice, if required.

It was during the invasion led by General Gnaeus Julius Agricola that the Roman forces reached the banks of the River Tay around the year AD 79. An area a short distance from where the River Almond joined the Tay was chosen to construct a fort. This was also the furthest point along the River Tay that the Roman ships could reach. The resulting structure is best known today as Bertha, although it is debated whether this was the name given to it by the Romans. It is believed they may have known it as Tamia, a historic name

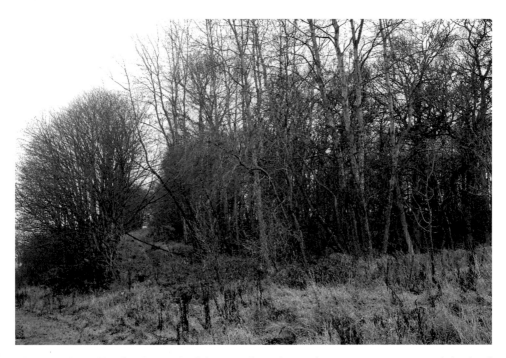

The area of woodland to the north of the city where the Bertha Roman Fort once stood. (Richard Webb, CC BY-SA 2.0)

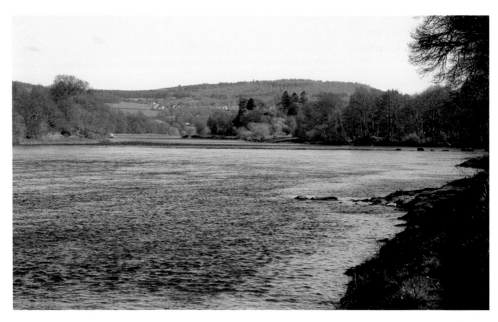

The River Tay flowing through the area where the Bertha Roman Fort once stood. (A. Melville, CC BY-SA 2.0)

for the River Tay, yet later historians who were unaware of the original name took the name Perth and adapted it to Berth or Bertha. An alternative thought is that 'bertha' may be the term used for wood in Cumbric, an ancient language used in northern England and the Scottish Lowlands.

The resulting fort was vast, occupying an area of almost 4 hectares, and was used as a supply base. A crossing point is also likely to have been constructed across the Tay beyond the point where the boats could reach; the fort would have controlled and protected this crossing. Historical maps show a bridge crossing the Tay, just beyond the point where the River Almond meets the Tay, which is believed to have been the crossing point constructed by the Romans, and a causeway that may have also been used. The site of a Roman station named Orrea is also shown, along with the location of the town of Bertha. This is likely to be the original settlement that was destroyed by floods. Due to silt building up in the Tay it had already become impossible to reach the town by boat, so when it was rebuilt a site a short distance downstream was chosen which remained accessible. This settlement grew to become Perth.

DID YOU KNOW?
Under the rule of Emperor Antoninus Pius, the Roma legions were able to advance as far as Perth but were unable to hold the territory. The Antonine Wall was built between the firths of the River Forth and the River Clyde, but it too soon fell.

Bertha was one of the forts that made up a fortified frontier known as the Gask Ridge, which runs from Glenbank to Bertha, covering around 23 miles. The Gask Ridge is part of a longer line of forts, which was further protected with watchtowers and smaller forts and predates Hadrian's Wall, which was constructed in AD 122, and the Antonine Wall, constructed in AD 142.

The remains of the fort were rediscovered in 1757, with further remains of the enclosure being discovered in 1771. Archaeological digs have found a road network, including at the

The junction between the Watergate and High Street where The Castle of Green once stood, under which a potential Roman temple was discovered.

entrance and within the fort itself, along with courtyard buildings, barracks and ovens. An aqueduct is also likely to have been constructed for the fort and it became the main site for the area. Other Roman artefacts were found throughout the area, indicating this was a significant encampment that spread well beyond the fort.

At the junction where the Watergate meets the High Street it is believed an important structure to the Roman era once stood. Although there is extremely limited information, historical maps indicate this to have been the location of the Castle of the Green, also known as the Kirk House and the Mercer House. It was not the property, however, that is of relevance, but what may have stood there previously.

It is said that around the end of the eighteenth century, Colonel Mercer, the Laird of Aldie, who owned the property, had the building demolished and a more modern and comfortable home built on the site. When undertaking the demolition, the stonemasons made an amazing and unexpected discovery. They found parts of an earlier building that remained below the property which they were taking down.

The discovery was made around 3 feet below the street level when they found two stone arches. They broke through the arches and discovered two rooms measuring approximately 26 feet by 14 feet. One of the chambers had a door to the north and the other a door to the south. Both were almost completely filled with rubbish, and the walls of the chambers are said to have been around 3½ feet thick. Unfortunately, the report does not go on to say what happened to the structure; it may well still exist below the street level to this day. There is, however, a theory as to what this may have been.

It is known that the ground level during the Roman times was lower than it is now, and for a building to be constructed using such heavy stones and incorporating arches is likely to have had some great significance. There is a belief that what had been discovered was a former Temple of Mars, which predated Perth and in which Agricola himself may have worshipped. It is thought that this was one of three temples built by the Romans, with the other two being in Bangor, dedicated to Mercury, and in Cornwall, dedicated to Apollo.

Of course, with such little information available it is impossible to state with any certainty whether there is any truth to the story. It would be hoped that even back in the eighteenth century a discovery of such potential significance would be explored more and documented; however, the site is marked on earlier maps as being the 'supposed site of a Temple of Mars' and so it must have originated somewhere and have been deemed to have sufficient validity for the cartographers of the time to add the reference to their maps.

DID YOU KNOW?
Although the main Roman fort is believed to have been Bertha, to the north of modern-day Perth, Roman artefacts have been found across the current city and evidence of a signal tower at St Magdalene's Hill to the south, giving clear evidence that the whole area was utilised by the Romans.

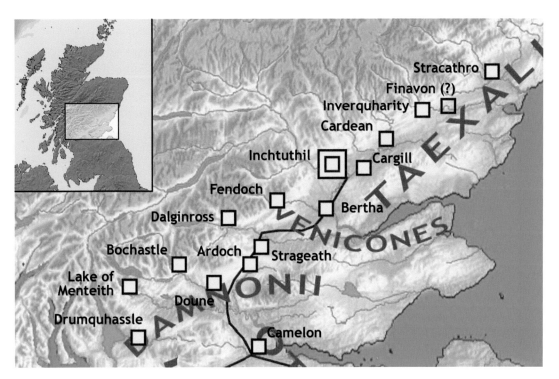

Map of the Gask Ridge, showing the position of Bertha within the network of forts. (Singinglemon, CC BY-SA 3.0)

2. The Siege of Perth

Perth has been visited by many notable people in Scottish history, including royalty; however, when King Robert the Bruce, possibly the most famous monarch, arrived at the town in 1313 it was far from a social matter.

At the time, Perth was under the control of the English who had taken it relatively unopposed in 1296. The city had relatively poor defences, with the castle having been destroyed by floods in 1210.

Under the control of King Edward of England, the defences of the town were considerably improved to include a defensive wall and moat fed by the River Tay and a lade. It seems the importance of Perth as a strategic crossing point for the River Tay and for storing supplies had been recognised by King Edward, and he was keen to hold the advantage. The city was fought over in the following years, yet it was Robert the Bruce who eventually delivered the decisive blow.

Bruce had been crowned in March 1306 and in response King Edward of England set about trying to reinforce his authority. This included his general, Aymer de Valence, establishing the heavily protected Perth as his stronghold to operate from. The forces of Bruce soon arrived at the walls of Perth and challenged General de Valence to leave Perth and meet him on an open field to do battle. The English general declined, yet indicated

An illustration of what Perth Castle may have looked like on a plaque at the North Inch flood gates.

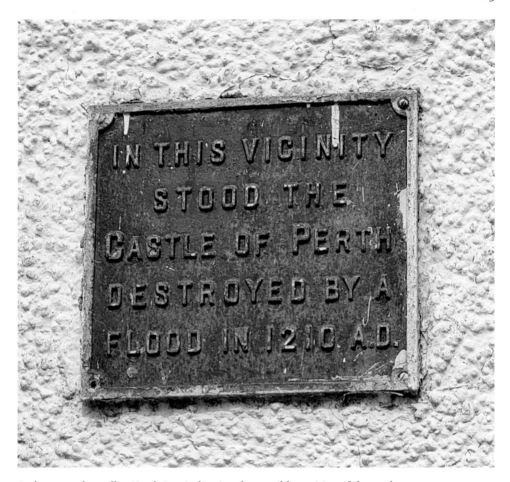

A plaque on the wall at North Port indicating the possible position of the castle.

that he would be willing to do so the following day. With King Robert having an army of around 4,500 men, he could have attacked the town; however, he was no doubt well aware how well protected Perth was, so with his army already weary from marching, he opted to camp nearby and rest in anticipation of a pitch battle the following day. He took his forces a few miles north where they pitched camp in an area of woodland at Methven.

DID YOU KNOW?
Although little is known about it, Perth did once have a castle as part of the city defences. Believed to have been of timber construction, it is known to have existed in the twelfth century, however the mound on which it stood was substantially washed away during floods in 1209. With royal visitors staying in Church-owned properties, the castle was never rebuilt.

The woodland of Methven, where King Robert's army camped and rested. (Richard Webb, CC BY-SA 2.0)

The limited ruins of St Fillan's Priory, where Robert the Bruce was provided sanctuary prior to escaping to the Highlands. (Ian S., CC BY-SA 2.0)

The English commanders, however, were not planning to stick to their word. The Scots were awoken in the early hours of the morning the following day by a sneak attack by the English army. With Bruce's men unprepared, they scrambled to get their armour and weapons to defend themselves. What followed was essentially a slaughter. While King Robert did manage to get to his horse, he was demounted several times before he was whisked away to safety. He was given sanctuary at St Fillan's Priory before heading to the Highlands.

By 1310, Bruce controlled much of Scotland north of the River Tay, though the country was also suffering a famine. He wrote to King Edward II, who had succeeded Edward I following his death in 1307, seeking to negotiate peace between Scotland and England. When Edward refused, Bruce set his sights on freeing the last remaining towns and castles held by the English, including Perth where it must have felt there were still unsettled matters.

Perth at that time was under the command of Sir William Oliphant, a Scottish knight who had been governor of Stirling Castle before being sent to Perth by King Edward. Bruce offered conditions for the surrender of the town, but these were refused by the authorities. A six-week siege followed, which proved to be largely unsuccessful. Perth was too well fortified and heavily supplied for a siege to cause many difficulties. Eventually, King Robert ordered his forces to retreat.

DID YOU KNOW?
King Robert the Bruce is not the only famous Scottish leader to cause extensive damage to Perth. After the Battle of Falkirk in 1298, William Wallace and his men entered the city under disguise and set fire to it as they retreated north.

While the English garrison believed that the Scottish army had given up on Perth, this was far from the truth. They had been monitoring the city to try to establish both a routine with the guards and where the shallowest point in the moats and marshes surrounding the defensive wall lay. Around a week later, Bruce and a small force returned under the cover of darkness. They brought ladders with them, and it is said that the sight of King Robert carrying a ladder himself and being one of the first to swim the moat, then holding up the ladder against the town walls while he stood neck deep in the water inspired the others that the king truly believed in the plan, which could be classed as ambitious at best.

The sneak attack was a success and control of Perth was quickly taken. It is said that the surviving English forces were set free from the town; however, their Scottish commanders who had been acting on behalf of King Edward faced much harsher treatment. Perth was finally back in the hands of the Scots, although this was not good news for the townsfolk. Bruce ordered that the town be ransacked and the walls, along with anything that may have remained of the castle, being completely destroyed. While this may seem harsh,

The sign in the lane that runs from George Street to Skinnergate indicates that the wall is a section of the original city defensive wall. This claim is questioned, however, and it is thought that it is more probable that the wall is built on top of the original city wall foundations.

The Town Lade was utilised as part of the town defences.

The section of wall that is said to be part of the original defensive wall.

the king knew that Perth remained a strategically important place and that he would struggle to continue to hold it while continuing his progress south. The fortifications were therefore destroyed to avoid the risk of Perth falling into English hands and becoming a stronghold for the enemies ever again.

The people of Perth were not willing to give up on their town and it was largely rebuilt within two years, although sites such as the castle were lost forever.

DID YOU KNOW?
After his execution in 1305, one of the 'quartered' body parts of William Wallace were displayed on the walls of Perth as a warning to all.

The Lade running alongside the supposed original defensive wall.

3. The Battle of North Inch

On 28 September 1396, a rather unusual battle took place on the North Inch, which at that time stood just outside the walls of Perth, in an attempt to settle a long-term Highland clan feud. Although there is some debate as to exactly which clans were involved. Some historians believe the evidence shows that it was an internal battle between the Clan Macphersons and the Clan Davidsons, both of which were members of Clan Chattan, a rather unusual and unique confederation of Highland cans; while others argue that it was the Macphersons and Mackintoshes of Clan Chattan who fought against the Clan Cameron. Other accounts indicate it may have been the Clan Kay or Quhele, a clan

General view of the North Inch from Rose Terrace, where the battle would have been watched by the king.

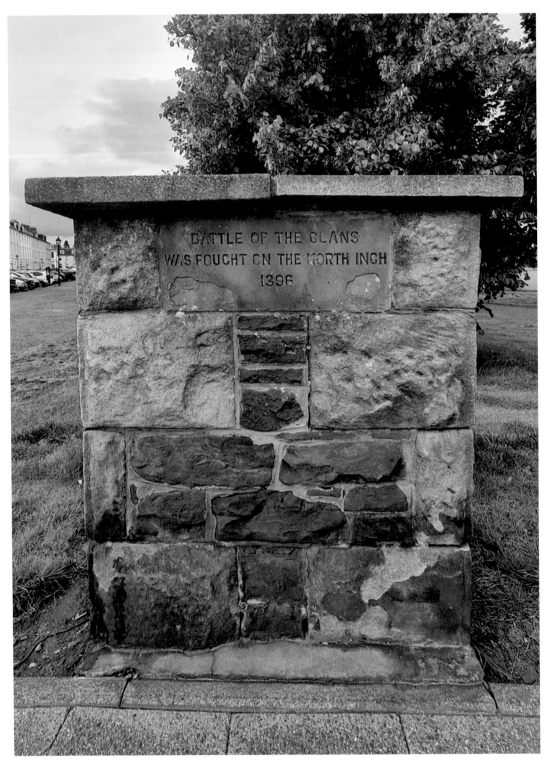

The memorial stone records that the battle took place on the North Inch.

which in itself remains largely unidentified. There does appear to be consistency in the agreement that the Clan Chattan was involved, and so for this section of the book we will work on the basis that the battle was between the Clan Chattan and the Clan Cameron due to most historians agreeing that there was indeed a long-standing feud between members of the Chattan Confederacy and the Camerons.

With so much uncertainty over exactly who was involved, it should be of no surprise that exactly what started the feud is unclear. It was, however, sufficient to have come to the attention of King Robert III, and to have been of significant concern or annoyance to him to warrant him taking action in order to try to bring it to an end. The king ordered a trial by combat. The Battle of North Inch, as it would become known, or the Battle of the Clans, would be the last judicial combat to be held in the country.

DID YOU KNOW?
Prior to the Battle of the Clans, the North Inch has been used for several trials by combat, fought between individuals.

The battle involved only thirty men on each side, all specifically chosen by the clan chief as being their best and most successful fighters to form a small force who would fight for victory. It was a fight to the death, with the winner being the first side to kill all those on the opposing side, and so while being chosen was certainly an honour, it was also, for most, a death sentence.

It was arranged for the battle to take place in the North Inch in Perth, and it was quite a spectacle. Stands were constructed for the gathering crowds to watch, along with a platform for the king to spectate – no doubt designed to give the best vantage point but also large enough to seat his entire royal court. A large area of land was dug down, which was to be the site of the battle, giving all around a good view from the higher ground that surrounded it. One of the sides, it is said, was one man short due to one of those chosen being seemingly too frightened to take part. The king initially ordered that one man on the opposite side steps down to ensure equal numbers, yet all refused to do so and were quite offended at the suggestion that any one of them may not want to fight for their clan. The matter was eventually resolved when a spectator became aware of the problem and came forward, offering to take the place of the missing man in exchange for a payment of a gold coin. The beginning of the event was marked with trumpeters and bagpipers signalling to both sides that the battle was to begin.

DID YOU KNOW?
Barriers were erected around three sides of the battleground to contain the fighting to a designated area. The fourth boundary was the River Tay.

Although there are no definite accounts, it is thought that each man on both sides had three crossbow bolts which were to be fired at the opposing side to start off the battle. While this may conjure images of a slaughter before the battle even really got going, it should be noted that the crossbows of the time would not be as powerful or accurate as those we see today, and they were being fired at moving targets by people who were not necessarily experienced in the use of the weapon. Once all the bolts had been discharged, the surviving forces came together in hand-to-hand combat using swords, axes and knives. Other versions, however, indicate that the battle was fought solely hand to hand with swords.

Sir Walter Scott gives an account of the battle in his 1828 novel *The Fair Maid of Perth*. In it he describes the desperate and ferocious battle that took place, with neither side gaining the upper hand, until the pipes sounded a retreat which allowed both sides to

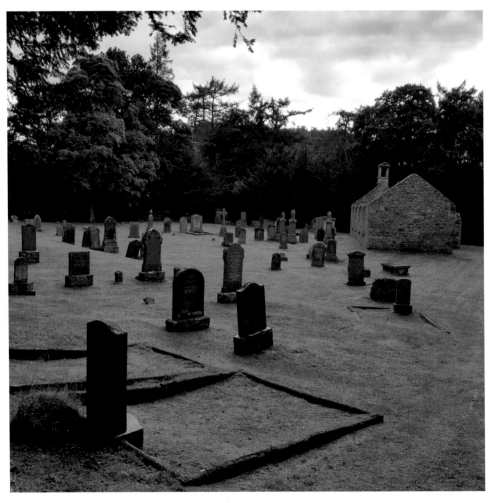

Rothiemurchus Old Parish Church and graveyard. It is here that Seath Mor Sgorfhiaclach, head of the Chattan Clan at the time of the battle, is buried.

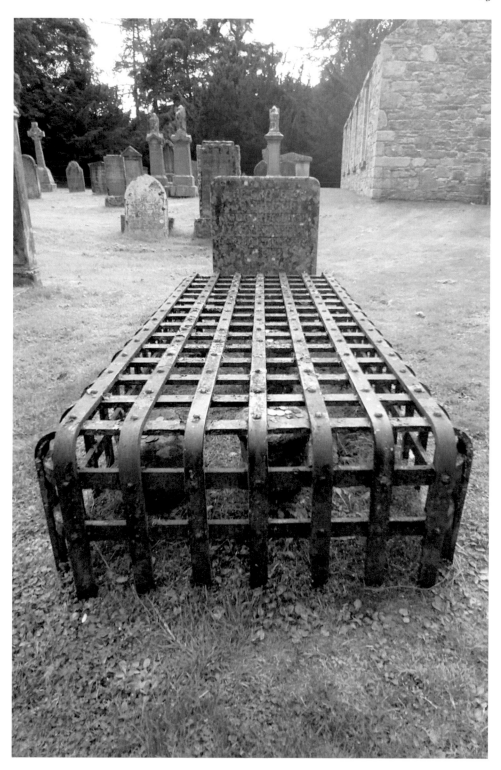

The grave of Seath Mor Sgorfhiaclach.

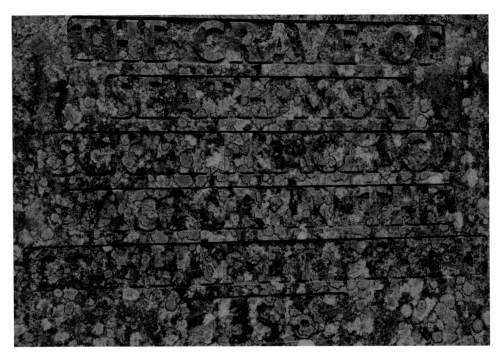

Although very difficult to read, the headstone says: 'Grave of Seath Mor Sgorfhiaclach Victor in the combat at Perth 1396'.

The Fair Maid's House, close to the North Inch. While the current building does not date back as far as the time of the battle, it does incorporate parts of a medieval structure.

separate for a rest. At this point he estimated that both sides had lost around ten warriors each in the initial clash.

After a break of around ten minutes, the opposing armies once again lined up against each other, this time moving to ground closer to the river, away from where their fallen and injured comrades lay. It is noted that one man, identified as Harry Smith, stood overlooking a beheaded corpse rather than joining the rest of the men to continue the battle. After a verbal interaction with the clan chief, Harry returned to his position, yet this pause had given others time to consider the contest and those they were fighting against. When the signal came to recommence battle, it is said to have been at a slower pace, perhaps a sign of the exhaustion of the combatants or perhaps a sign the men were losing their enthusiasm for the battle or maybe a mixture of both.

While the fighting paused for a second time, the king is said to have indicated his desire for it to be brought to an end, hoping that there had been enough bloodshed for both sides to feel vindicated and end their feud. The Duke of Albany, however, countered the king's argument, pointing out that both clan chiefs remained alive and that the king had assured them he would allow the battle to be fought to a decisive end. Robert made his unhappiness at the situation be known before the piper's signal was given once again for battle to resume.

There seemed to be renewed energy in the fight at this point – possibly showing the fighters shared the king's desire to bring the fight to a close. It eventually did so when only one man remained alive on the Clan Cameron side. Faced with eleven of the Clan Chattan still living, he took matters into his own hands and leapt into the River Tay, accepting that he would either be able to swim to the other side and safety or he would be swept away and drowned. Although the surviving Chattans were all heavily injured, he would have known he stood no chance against them and so either option probably seemed favourable to what he would face if he stood and fought.

The victory was awarded to the Clan Chattan; however, it remains debatable as to whether the battle actually did any good in resolving the issues and disputes between the clans. All that was achieved was the loss of the best fighters on both sides – at the expense of the Perth taxpayers.

DID YOU KNOW?
The grave of Seath Mor Sgorfhiaclach, clan chief of Clan Shaw and 'victor in the combat at Perth in 1396', is said to be cursed. While many assume the metal cage covering the grave is to protect against body snatchers, the body was buried long before body snatching was a concern. The iron grate was not fitted until around the 1980s, it is said to prevent anyone from touching or removing the cylindrical stones which sit on top of the grave after misfortune fell upon a number of people who had done so.

4. The Murder of King James I

King James I of Scotland was born at Dunfermline Palace in July 1394. As the youngest son of three, he may never have been expected to become king, but his life was turbulent from his birth and fate would see him be crowned monarch.

James' parents were King Robert III and Queen Annabella Drummond. King Robert had in fact been christened John Stewart; however, as the name John was unpopular with the Scottish public at the time following the rule of John Balliol, he later changed it to Robert when he was to become king. By the time Robert succeeded his father, he was already in his fifties and was crippled after a horse-riding accident. He therefore had no confidence in his ability to rule, something that must have influence James during his upbringing. King Robert oversaw the Battle of the Clans, which was discussed in the previous chapter.

Dunfermline Palace, the birthplace of King James I.

The future King James was born in 1394 and by the time he was eight years old, both of his elder brothers had died in what were considered even then to be mysterious circumstances. King Robert was concerned enough that he arranged for James to be sent to France for his own safety; however, there was to be a further twist of fate when his ship was intercepted by pirates, who took the young James prisoner and handed him over to King Henry IV England. Robert did not take the news well, and he died a few months later.

A ransom was demanded for the release of King James; however, his uncle, the Duke of Albany had been appointed regent, allowing him to rule the country on James' behalf. With Albany being suspected as having a part to play in the deaths of both of James' brothers, along with James himself being captured by the English pirates, he had no inclination to pay the ransom and lose his power. Instead, having been appointed by the government as their representative to negotiate the ransom fee he could use this to prolong the king's captivity. He did however manage to negotiate the fee for his own son's freedom, who was also being held. James ended up being held for eighteen years, during which time he became married, until King Edward VI finally took the initiative and agreed a price for James to be returned to Scotland in 1423 with what became known as the Treaty of London.

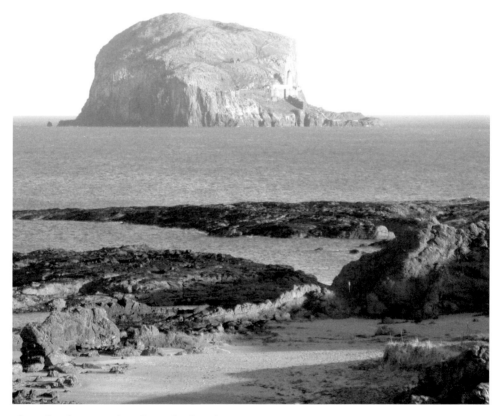

The isolated Bass Rock in the Firth of Forth.

The ruins of the Bass Rock Castle, also used as an impregnable prison, leading it to be more recently referred to as Scotland's Alcatraz. (Mike Pennington, CC BY-SA 2.0)

James was determined to take control of his kingdom, and one of his first moves was to exile the members of his uncle's family. Walter Stewart of Lennox, who had been notably vocal against the king's release was held on the Bass Rock while waiting to be transported to France. This isolated, barren castle prison is thought to have been specifically chosen to send a message out to everyone to warn of the consequences of speaking out against the king. Others were executed when there was a failed attempt to move against the king. James was not afraid to make tough decisions and was considered to be a firm but fair ruler who brought stability back to Scotland after a long period of weak monarchs. In doing so, he also created many enemies and was unpopular within the population of Scotland.

A plot was hatched to assassinate the king by Sir Robert Graham, a supporter of the Duke of Albany. He soon managed to gain support from other nobles who were unhappy with the King's ruling and a plan was put in place.

In February 1437, King James was staying at the Blackfriars monastery in Perth, which stood in and around the street that takes its name from it, Blackfriars Wynd. As Perth had no castle by that time for the monarchy to stay at, other locations had to be used and the monastery became one frequently used as a safe and secure residence. His queen was travelling with him, along with an entourage which were mostly kept in separate quarters from the royals. Sir Robert Stewart, the chamberlain of the royal household was an associate in the assassination plans, although as the king's cousin there were not any

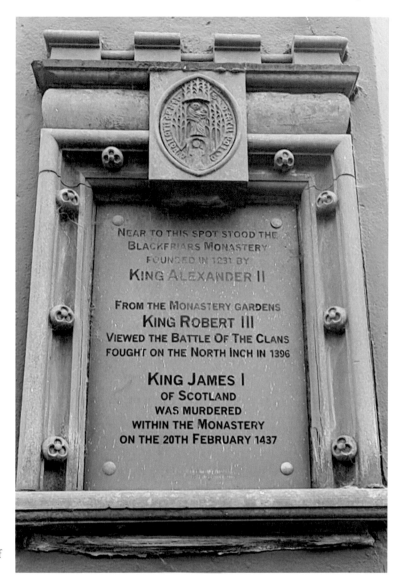

NEAR TO THIS SPOT STOOD THE
BLACKFRIARS MONASTERY
FOUNDED IN 1231 BY
KING ALEXANDER II

FROM THE MONASTERY GARDENS
KING ROBERT III
VIEWED THE BATTLE OF THE CLANS
FOUGHT ON THE NORTH INCH IN 1396

KING JAMES I
OF SCOTLAND
WAS MURDERED
WITHIN THE MONASTERY
ON THE 20TH FEBRUARY 1437

A plaque marking the approximate location of Blackfriars Monastery.

concerns with him travelling with the royal party. This allowed him to use his position to allow the other plotters to enter the monastery.

On 20 February, the conspirators gained access to the property and made their way to the king's chamber. Aware that something untoward was happening, the king sought to make his escape. There are conflicting versions as to how he did so, but he is said to have found his way into a large drainage system – some say a sewer – but he found his exit route blocked. Faced with no other option, he returned and re-entered his chamber just as the assassins were about to leave to look elsewhere. He was then grabbed and taken captive before being murdered in cold blood.

The site of the Charterhouse. The monument, which stands on King Street, bears the following inscription: 'Within these grounds stood the Carthusian monastery founded by King James I of Scotland in 1429. It was the only house belonging to this order in Scotland. In the precincts of the monastery were buried the royal founder, his queen Joan Beaufort and Margaret Tudor queen of King James IV.'

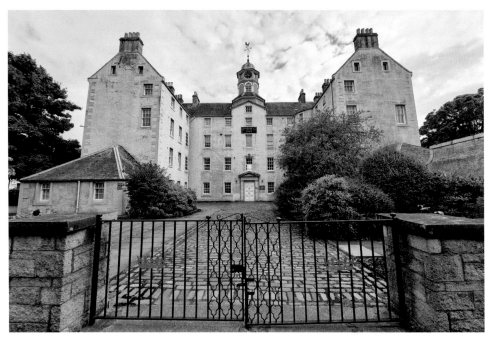

The King James VI Hospital is built on the site of the Charterhouse. Although the stone states the hospital was founded in 1587, work on the current building did not start until 1749.

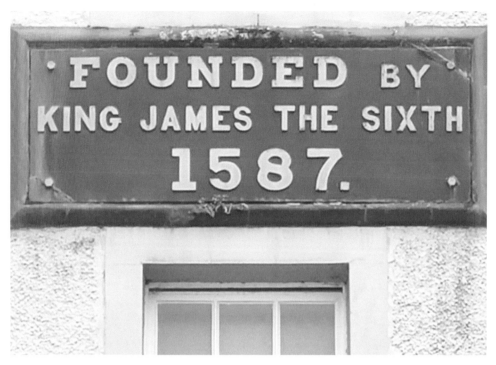

The stone on the building stating it was founded in 1587.

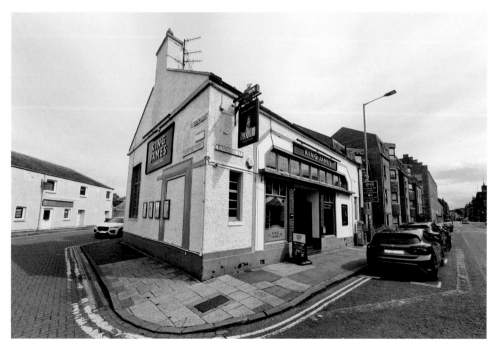

The King James pub. Archaeological works have given strong evidence that this building is constructed in part from the remains of the Blackfriars Monastery.

DID YOU KNOW?
Legend says that a woman named Catherine Douglas, or Kate Barlass, tried to
prevent the assailants from entering the king's chambers by putting her arm
through the brackets on the door and wall to hold it shut. Eventually her arm was
broken, causing severe injury; however, her act of bravery bought the king time to
make his escape. While the story has been passed down over the years, there is no
evidence of her heroic act.

His queen had been injured in the struggle, yet with all the commotion going on she
managed to make her escape. Her priority was to secure the safety of their son and got
word sent to Edinburgh as to what had happened. Her revenge was swift and brutal.
Within six weeks all those involved, along with anyone who had offered them shelter
since, were brought to Stirling to be executed. In total, over thirty men faced death, mostly
by being hung, drawn and quartered. This was designed to send a strong message out to
any surviving supporters of the failed coup of what awaited them if another attempt was
made against a future monarch.

Perhaps the most ironic part of these years of scheming and back-stabbing is that they
did little to change much other than remind those in power of the real dangers which
they faced.

The murder of King James has once again hit the headlines when, in 2017, the BBC and
other news agencies announced a project had been launched to try to find the tomb of the
king. It tells that he had plans to build a monastery to compete in size and prominence
with that of Westminster and to have the University of St Andrews closed and moved to
Perth, creating a city that would be classed as grand as almost any other across Scotland
and England. He, of course, never saw this come to fruition and his body was buried at
the Charterhouse Monastery. This was, in turn, destroyed in the Reformation and as a
result the location of the grave was lost. The plans set out were that if the grave could be
located, a visitor centre could be created around it as a tourist attraction and to tell the
story of King James.

DID YOU KNOW?
It is said that it was the king himself who had the drains through which he tried
to make his escape blocked. Having become frustrated at losing tennis balls
into the drain, it is claimed her instructed them to be closed just days before his
assassination.

5. The Reformation in Perth

The arrival of St Columba during the sixth century saw the growth of Catholicism across the country. After Scotland became unified St Andrews grew as the home of the Catholic Church, resulting in the town being referred to as 'Scotland's Rome'.

The Catholic Church yielded considerable power in the country for centuries, until the Protestant faith began to grow in popularity during the sixteenth century across Europe. It is understandable that the Catholic Church was reluctant to give up the authority and privileges it held, so when Protestantism reached Scotland they fought to subdue it. The first example of the extremes they were prepared to go to was in the treatment of a young student in St Andrews named Patrick Hamilton. He had heard the preachings of Protestant leaders such as Martin Luther while in Europe and began to discuss with and teach his fellow students about the new faith. This brought him to the attention of Archbishop James Beaton, who ordered Hamilton's arrest, leading to the young student temporarily returning to mainland Europe. He soon returned, however, and despite his concerns accepted an invitation from the Archbishop to meet at St Andrews Castle to discuss matters. His suspicions proved to be correct, and he was arrested and imprisoned. After a mock trial, he was convicted of heresy on the basis of accepting false doctrines and sentenced to death. His execution was horrific; he was burned alive, but due to damp wood being used the fire kept going out. In the end it took around six hours for him to pass. Rather than quell the Protestant movement, those who witnessed Hamilton's torment, and in turn those who heard about it, began to question the humanity of the Church.

England became a Protestant country in 1532 following King Henry VIII breaking away from the Catholic Church when Pope Clement VII refused to annul his marriage to Catherine of Aragon. This allowed the Protestant faith to take hold and Thomas Cranmer, leader of the Reformation in England, later ruled the king's marriage to Catherine to be unlawful, leaving him free to remarry as he wished. This weakened the Scottish position somewhat and the execution of Henry Forrest in St Andrews on similar charges to Patrick Hamilton brought further unrest within the population of Scotland.

In 1539, Cardinal David Beaton succeeded his uncle as Archbishop of St Andrews. Cardinal Beaton took an even harsher stance against the Protestant movement, leading to him earning a reputation of being in league with the Devil. He was an advisor to King James V, but when the king died in 1542, he saw his influence was at risk not just within the Church but within the country. He subsequently took the desperate measure to become one of the regents for the infant Queen Mary, which ultimately failed, harming his reputation further.

Meanwhile, King Henry VIII of England gained agreement that his infant son, Edward, would be married to Queen Mary when both came of age in the Treaty of Greenwich. Realising the implications of the queen being betrothed to a Protestant king, a marriage

The initials 'PH' in the cobbles mark the site where Patrick Hamilton was executed in St Andrews.

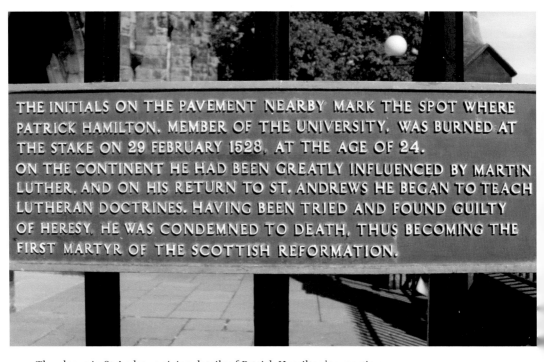

THE INITIALS ON THE PAVEMENT NEARBY MARK THE SPOT WHERE PATRICK HAMILTON, MEMBER OF THE UNIVERSITY, WAS BURNED AT THE STAKE ON 29 FEBRUARY 1528, AT THE AGE OF 24. ON THE CONTINENT HE HAD BEEN GREATLY INFLUENCED BY MARTIN LUTHER, AND ON HIS RETURN TO ST. ANDREWS HE BEGAN TO TEACH LUTHERAN DOCTRINES. HAVING BEEN TRIED AND FOUND GUILTY OF HERESY, HE WAS CONDEMNED TO DEATH, THUS BECOMING THE FIRST MARTYR OF THE SCOTTISH REFORMATION.

The plaque in St Andrews giving details of Patrick Hamilton's execution.

was instead agreed between the queen and Francis II of France, which remained Catholic. King Henry, enraged that the Scots authorities had broken the treaty and determined to break up Scotland's alliance with France, started military action in Scotland which started a period which became known as the 'Rough Wooing'.

With the country in a state of turmoil, Cardinal Beaton again sought to quell the Protestant movement and set his eye on an upcoming reformer named George Wishart, who had risen in popularity. After an assassination attempt failed, along with moves to try to discredit Wishart, Beaton had him arrested and burned to death outside St Andrews Castle. He had underestimated the public opinion, however, with supporters of Wishart seizing control of the castle shortly afterwards and murdering the cardinal. They held the castle for almost a year, hoping that King Edward's Protestant forces would arrive to free them; however, it was the French navy who arrived first and bombarded the castle with artillery, taking those inside prisoners as galley slaves.

Amongst those taken by the French was John Knox, a former bodyguard of Wishart. When released by the French, he moved initially to England before returning to Germany and eventually came back to Scotland in 1559. Knox went on to lead the Reformation in Scotland, with the country officially adopting the Protestant faith in 1560. A year later, in 1561, Mary, Queen of Scots returned. Finding herself a Catholic queen in a Protestant

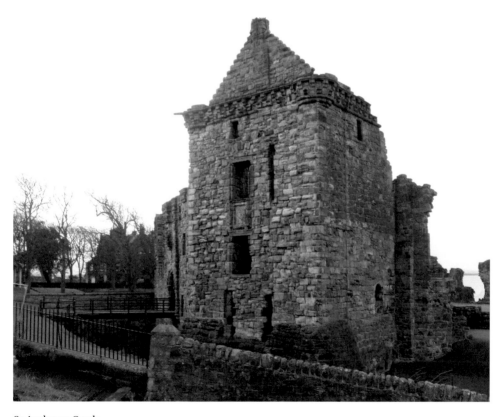

St Andrews Castle.

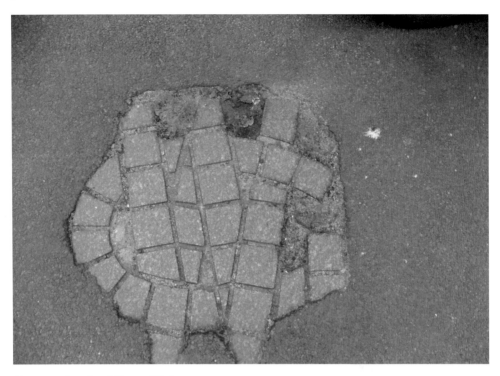

The execution site of George Wishart.

country, she was at odds with Parliament and John Knox, who remained as a leader of the reformed Church.

Throughout the period of the Reformation towns and cities across the country suffered extensive damage, and Perth was no different. Perth in fact became one of the main centres for the Protestant Reformation, which may be down to an incident that happened in 1544 which gave the town its own martyrs. The incident followed the removal of John Chartuous from his position as Provost of Perth in 1543. Chartuous was known to have favourable views regarding the reformation and was replaced by Alexander Marbecke, a devout Roman Catholic. Such a move was seen as provocative at best.

In January 1544, Friar Spence was delivering a sermon in Perth and while reinforcing the necessity of prayer to the saints, he was interrupted by Robert Lamb, a town burgess, who accused the friar of delivering a false doctrine and urged him to tell the truth. In shock, Spence is said to have assured Lamb and the rest of the congregation that he would do so but instead later made a complaint to Cardinal Beaton, who was visiting the town along with the Earl of Arran, acting in his capacity of regent to King James, along with other nobles. Robert Lamb and his wife Helen Stark were brought in front of the cardinal and king's regent to answer to the accusation; yet, instead of making any form of plea, Lamb confessed openly to have acted as accused and stated that he saw it as his duty to ensure that the people of the town were told the truth – meaning Presbyterianism.

Unsurprisingly, they were arrested. Four other men were also named in the charges and subsequently arrested: William Anderson, James Raueleson and James Founleson,

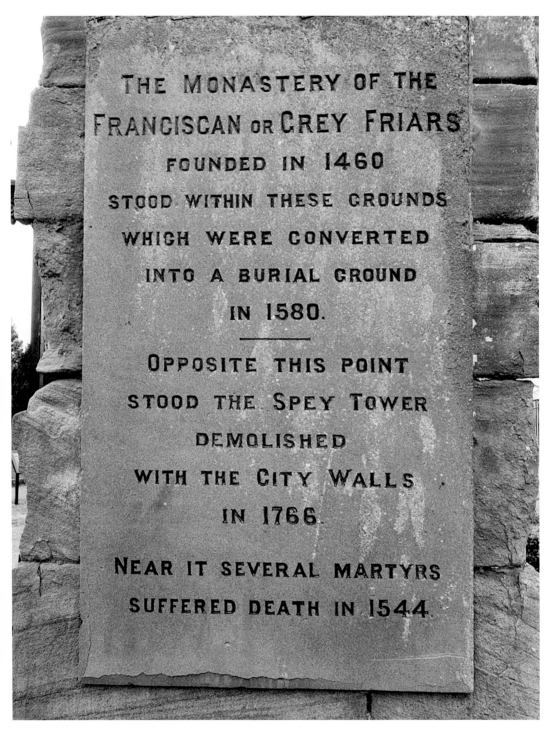

THE MONASTERY OF THE
FRANCISCAN OR GREY FRIARS
FOUNDED IN 1460
STOOD WITHIN THESE GROUNDS
WHICH WERE CONVERTED
INTO A BURIAL GROUND
IN 1580.
———
OPPOSITE THIS POINT
STOOD THE SPEY TOWER
DEMOLISHED
WITH THE CITY WALLS
IN 1766.

NEAR IT SEVERAL MARTYRS
SUFFERED DEATH IN 1544.

An inscription at the gate to Greyfriars Burial Ground, off Canal Street, tells that the Spey Tower once stood opposite. This is the tower in which the Protestant reformers were imprisoned pending their execution, which took place beside the tower.

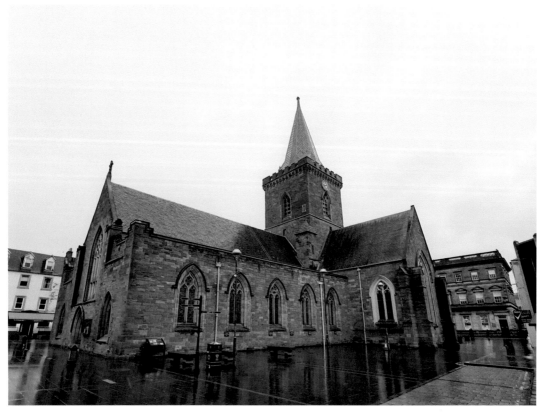

St John's Kirk, where John Knox delivered his fiery sermon which sparked the Reformation in Perth.

who were accused of hanging an effigy of St Francis and attaching rams' horns to the head and a cow's rump to the rear, along with James Hunter, who was said to have been of simple mind and was charged with being in the company of the others. Helen Stark, who had very recently given birth, was charged with refusing to pray to the Virgin Mary during the birthing process, instead praying to Jesus. All were sentenced to death. This is said to have caused great unrest in the town as the residents had been assured by the Earl of Arran that he would see to it that they would not be convicted. In addition, there were other priests who could have spoken in defence of the accused, yet none dared speak up against Cardinal Beaton for fear of their own life.

All were led to the execution site surrounded by a large number of armed guards, such was the fear that the townsfolk would try to free them. All of the men were hung, and while Helen begged to die with her husband, she was not permitted and was instead forced to watch his execution, with the small mercy that she was allowed to say her goodbyes to him. She was then taken to a deep pool of water where she was drowned, with some reports saying she was put in a sack which was tied at the top before she was thrown into the water. She still held her baby as she was led to the executions, and this was taken from her and handed to nurses to look after.

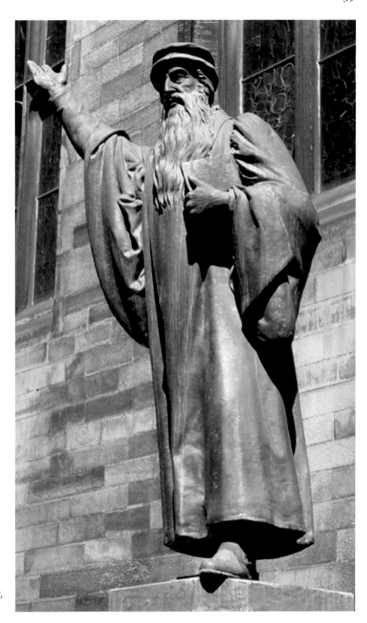

Statue of John Knox
delivering a sermon
at the New College in
Edinburgh. (Kim Traynor,
CC BY-SA 2.0)

While the actions of Cardinal Beaton may have boosted support for Presbyterianism in Perth, action taken by Mary of Guise, the queen regent, in 1559 may have catapulted the Reformation into reality in the town. Mary had already angered the supporters of the new faith by ruling that the Catholic faith should be observed at Easter. John Knox returned to Scotland in May, and he became well known for delivering fiery sermons that stirred the attendees into action. Some blame his sermons for encouraging the destruction of religious buildings, while others say he sought to discourage any violence.

However, after his sermon in Perth, which was delivered at St Johns Kirk on 11 May 1559, a huge crowd gathered to hear him preach, after which he was ushered out and away from the church in secret. Meanwhile, violence erupted inside, with symbols of the Catholic faith being destroyed, before the mob spilled out and other religious buildings across the town faced a similar fate.

DID YOU KNOW?
Perth declared itself to be a Protestant city, along with Dundee, in 1559, a year before the faith was officially adopted across the country.

The civil unrest continued for days afterwards, prompting the regent to seize the opportunity. She used the actions in Perth to persuade the nobles that the reformers were not people of religion but were instead seeking to over throw the authority of the government. She amassed an army, estimated to be of around 5,000 troops, and marched on Perth. While her army set up temporary camp at Auchterarder, she received a letter from the Congregation of Perth assuring her that their actions were not a rebellion yet solely to give the people the choice for a religious settlement. The letter also called upon supporters of the Reformation from across the country to come to the aid of the people of Perth, warning the regent that if she made a move into Perth she will need to be prepared for battle.

This, it seemed, was sufficient to make Mary pause to further consider the correct course of action. While agreement was reached for both sides to disperse, the regent ultimately decided to proceed to march on Perth regardless. Despite the threats of battle, she was allowed entry to the town with her French army unopposed. Her first action was to remove Lord Ruthven from his position as provost and dismiss the rest of the town magistrates, before installing John Charteris of Kinfauns as provost. She remained in the town for a few days, staying either at Blackfriars Monastery or at the Provost of Methven's home. During this relatively quiet period of time, the French musketeers who formed part of her army took the opportunity to do some ad hoc practice in the streets of Perth, a decision which would lead to increased tension between the towns folk and the regent's forces when one of the musketeers misfired, hitting and killing a young boy. The child was the son of Patrick Murray, a principal supporter of the Reformation, and she was said to have commented that it was a shame it was not the father who was killed instead of the boy.

When Mary departed Perth, she left a garrison of around 600 to defend the town from further action by the reformers, essentially imposing Catholicism by martial law. This act was seen as a step too far and prompted the Earl of Argyll, the Earl of Menteith, the Laird of Tullibardin and, perhaps most significantly, Lord James Stuart, the half-brother

of Mary, Queen of Scots, to turn their support to the Reformation and join the Lords of the Congregation. They left Perth and travelled to St Andrews, ignoring the regent's orders for their return, where they later met with John Knox and other leaders of the Reformation. Knox went on to deliver a number of sermons, including at both the Holy Trinity Church in St Andrews and St Andrews Cathedral, despite threats made against his life should he even enter the building.

While many say it was these sermons at St Andrews which triggered the Reformation, it is probably more accurate to say it was the events in Perth which did so. Military battles followed as Protestantism swept the country; the war may have continued for years, had it not been for the death of Mary of Guise in June 1560. England sent forces to aid against her French army, and the Treaty of Edinburgh was agreed and signed the following month by the French, Scottish and English. The implications of the treaty was that all French military were to withdraw from Scotland and in August 1560, with the majority of nobles by then supporting the Reformation, a new government was formed and the country declared to be Protestant.

The Holy Trinity Church, St Andrews. (David Dixon, CC BY-SA 2.0)

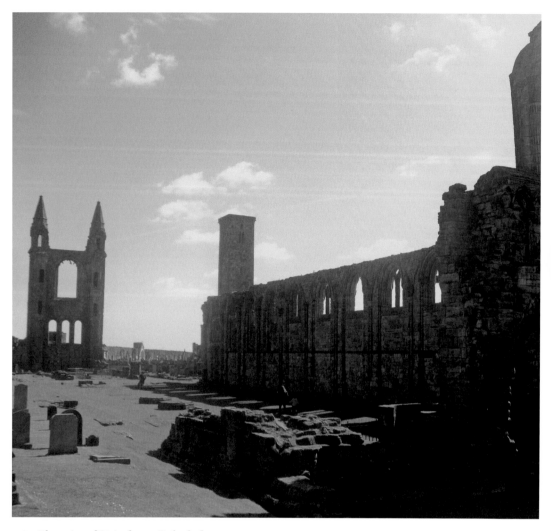

The ruins of St Andrews Cathedral.

DID YOU KNOW?
In 1618, at a General Assembly held in Perth, new rules were brought into place by King James VI with regards to worship. Known as the Five Articles of Perth, these were permitting private baptisms, private Communion for the ill and infirm, kneeling to receive Communion, confirmation to be by a bishop and the observance of specific holy days. These were deeply unpopular, yet ministers who refused to accept them were either removed from their church or imprisoned.

6. The Raid of Ruthven

While Scotland may have officially become a Protestant country in 1560, this did not end the fighting over religion.

When Mary, Queen of Scots was forced to abdicate in 1567, her infant son, James, was her heir. Aged just thirteen months old, regents ran the country on his behalf until he was deemed to have come of age. In 1579, aged just thirteen years old, he was proclaimed as an adult ruler. While every attempt had been made to ensure James was raised under the Protestant faith, concern was raised at the influence a man named Esme Stewart was having over the young king. Esme was the cousin of James' father, Lord Darnley, who had been murdered when James was still a baby. It was this murder which escalated Queen Mary's downfall. He arrived in Scotland from France in 1597 and quickly struck up a strong bond with James, leading to him being given the title the Duke of Lennox followed by subsequent titles. King James also showered him with gifts. While Esme had converted to the Protestant faith, he was still seen as being pro-Catholic by many, which led to the concerns that he may be able to convert the young and impressionable King.

A plot was hatched to remove James from any sway that Esme may have over him in quite a bizarre and risky way. In August 1582, while King James was enjoying a hunting trip to Perthshire, he was invited by the Earl of Gowrie to stay at his home – Ruthven Castle. James was travelling back to Edinburgh at the time with a small group of attendants and, sensing no cause for concern, he accepted the offer to break up the journey. Upon arriving at the castle, however, his feelings changed when he realised there were a large number of other nobles, some of who he didn't know, also at the castle. Unknown to the king, there were also a large number of armed soldiers positioned across the estate which surrounded the castle. Keen not to create an issue where there may not have been one, the king did not raise his worries and the evening passed smoothly before he retired to bed for the night.

DID YOU KNOW?
The conspirators did not initially plan to lure King James to Ruthven; however, the king's party became aware of a plot against him. Unaware that the Earl of Gowrie was one of those planning the kidnap, he was informed of the danger the king faced, allowing him to change plans and instead invite the king to Ruthven Castle.

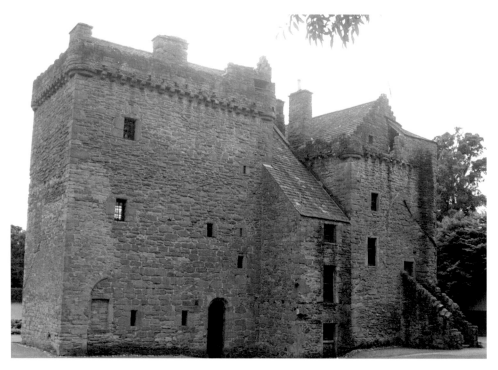

Ruthven Castle, now known as Huntingtower Castle.

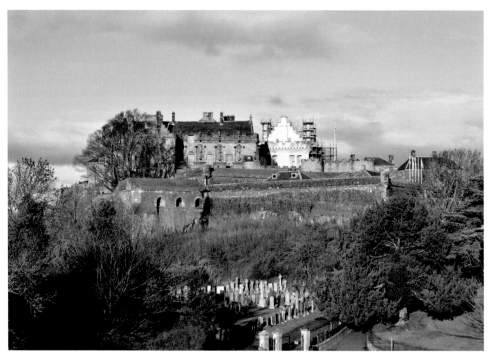

Stirling Castle, where James was taken to from Perth.

In the morning, soon after he awoke, he called for his attendants so that he might get ready to depart the castle and complete the journey back to Edinburgh. To his surprise he saw the Master of Glamis at the door to his chamber. James explained his desire to leave, but was told by the Master of Glamis it would be better if he stayed. When James tried to physically leave the room, the way was blocked by Glamis and he was forced back into his chamber. Aged just sixteen years old, the king is said to have burst into tears when realising that he had been imprisoned. His attendants were ordered to leave the castle, and while James was being held against his will, he was treated well and respectfully. A list of demands were presented to him by his captors essentially demanding that Scotland be ruled without the influence of France or the Catholic faith.

The Earl of Arran rode to the castle with a small force to try to free the king, yet instead he was captured and sent to Stirling Castle. The Duke of Lennox also attempted to rescue his close ally and friend, yet despite being allowed into the castle to see him, he was quickly forced to depart along with the nobles who had accompanied him. With the king

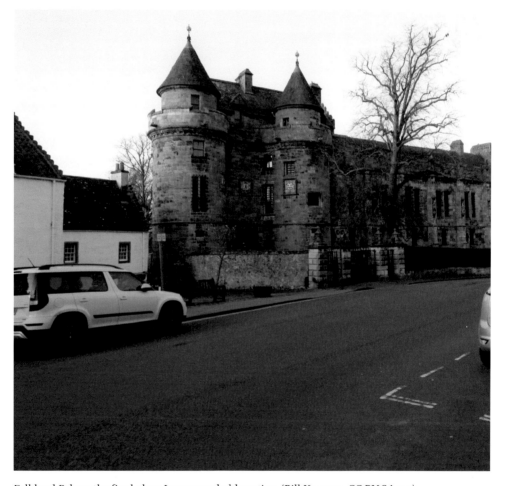

Falkland Palace, the final place James was held captive. (Bill Kasman, CC BY-SA 2.0)

shouting to Lennox that he was being held captive prior to his departure, his captives realised they would have to do something to create the illusion that this was not the case. He was allowed to be seen apparently freely walking in Perth, although in reality he was being closely guarded. Knowing he had no option but to accept his captors' demands, King James did as he was asked, including issuing written proclamations that he was staying at Perth through his own choice and that any thoughts about rescue attempts should be dismissed.

James was moved to different lodgings and such was the security around him no one could get close to freeing him. He was enticed to write a letter dismissing the Earl of Lennox and, although Lennox had built a group of supporters, he realised that he would not be able to free James and eventually returned to France, where he died in early 1583.

While James appeared to be complying with his captors demands, he was all the time looking for an opportunity for escape. This apparent compliance may have led his guards into a false sense of security as they apparently became a bit more relaxed about who James spoke to. They knew that to keep the pretence that the king was not being held prisoner he would have to be allowed to speak to some nobles. James ensured he was speaking to the right ones so he could plan his escape. In May 1583, he made his way from Falkland Palace to St Andrews, where the nobles he had prepared were awaiting him and he was ushered into the castle. With the gates closed, he was finally freed from his captivity.

In a surprising act of leniency, he later declared that he was willing to forgive all past offences for those involved in him being kidnapped and held against his will if they show remorse and sincerely ask to be pardoned, which all did. This was not, however, the end of matters for the Earl of Gowrie. He secretly set about trying to plan another conspiracy against the king, and when this was discovered he was shown no mercy. He was convicted of high treason and on 4 May 1584 he was beheaded.

DID YOU KNOW?
Queen Elizabeth of England was aware of, and supported, the actions against King James. She is said to have sent money to pay for the guards who ensured the king was kept captive; however, the sum promised was not delivered which was, in part, responsible for the ultimate failure of the plot.

Rohallion Castle, near Birnam. It is here that it is said the Earl of Ruthven hid after the king's escape. (Ronnie Leask, CC BY-SA 2.0)

7. The Perth Witch Trials

When witches are raised in conversation today it often conjures up an image of a green-skinned wicked old woman dressed in black and riding her broomstick. Persecution of actual people seems like some something distant that occurred in another place. The town of Salem is frequently mentioned when talking about historic witch trials. Yet the reality is that witch trials took place across Scotland, with virtually no town unaffected. It is estimated that around 4,000–6,000 innocent people were persecuted and prosecuted in Scotland on a charge of witchcraft, although due to the lack of records this could be far higher.

It was Mary, Queen of Scots who introduced the Witchcraft Act in 1563. Her reign coincided with religious upheaval, as the Protestant Reformation eroded Catholic dominance and dismantled religious institutions. As a Catholic, Queen Mary had to forge a tenuous truce with Protestant leaders. The new Protestant ethos slightly eased restrictions on women compared to the Catholic Church. While many believe that the witch trials were to crush the old Celtic traditions, this is inaccurate as Scotland had already been a Christian country for centuries. Only a tiny proportion of those accused were midwives or herbalists, the vast majority were simple townsfolk who, for whatever reason, found themselves under suspicion.

The impact of the Witchcraft Act was not immediate. Queen Mary did not live long enough to see the devastation that it would cause and under her reign there were relatively few trials. Perhaps if she had lived longer the outcome would have been different, as it was her son, King James VI, who first learned of the actions being taken across Europe against the seeming scourge of witchcraft before using the Act to impose his own beliefs.

In 1598, King James was wed to Anne of Denmark. Their wedding, held via proxy in Copenhagen, was followed by Queen Anne's storm-hindered voyage to Scotland, eventually seeking shelter in Norway. Frustrated at the difficulties his new wife was encountering while travelling to Scotland, James decided to sail to Norway, where they

DID YOU KNOW?
Due to the nature and length of witch trials, they were often expensive. There are numerous records within the archives that reveal everything had to be paid for, including the time of the torturer, rope to bind the accused, and wood or tar to burn them. Town authorities were required to meet the costs, but these were recovered from the family of the accused wherever possible. It is difficult to understand the torment they faced, having to watch a loved one suffer horrifically and then being asked to pay for it!

formally married in Oslo. They then returned to Denmark to celebrate their marriage, and when James arrived he discovered the country was in the midst of a witch hunt frenzy.

King James, a keen theologian, became engrossed in witchcraft beliefs during his Denmark visit and sought to discover as much as he could about them: how a witch would gain their powers, what they were capable of doing, how to identify a witch and, of course, how to terminate one. He also learned of the *Malleus Maleficarum* (the Hammer of Witches), a 1486 guidebook advocating the existence and extermination of witches written by Johann Sprenger and Heinrich Kraemer, two Dominican friars from Germany. The book had been produced following a papal bull issued by Pope Innocent III in 1484 which deplored the spread if witchcraft in Germany and authorised the two friars to eliminate it.

When it came time for King James and his queen to return to Scotland, the journey was plagued with storms, rough seas and instability in the fleet, leading King James to wonder if there was something else at play here rather than just the weather conditions. When a Danish minister blamed a well-known local woman of witchcraft, and using her powers to make the loads in the royal fleet unstable, King James turned his attention to any potential witches in Scotland. The trial that followed became known as the North Berwick Witch Trial and is known not only for being an extensive trial, but also being

The gryphaea fossil, believed to be a sign that the Devil was in the area due to people believing that these fossils were in fact claws the Devil had shed.

The remains of St Andrews Old Kirk in North Berwick. It was claimed that witches met within the kirkyard to plot against the king. (Richard Sutcliffe, CC BY-SA 2.0)

brutal, with the king himself overseeing some of the torture sessions. Lasting two years and accusing around seventy people, the trial reinforced witchcraft's reality in the public eye. King James in turn wrote his own book titled *Daemonologie*, which covered how to find and execute a witch. Published in 1597, this book predates the King James Bible.

To be accused of witchcraft, which could arise from almost anything, was in the vast majority of cases a death sentence. And in Scotland the implications of an accusation went even further. The 1563 Witchcraft Act included the following:

Nor that na persoun seik ony help, response or cosultatioun at ony sic usaris or abusaris foirsaidis of Witchcraftis, Sorsareis or Necromancie, under the pane of deid, alsweill to be execute aganis the usar, abusar, as the seikar of the response or consultatioun.

A rough translation is that anyone who is seen to assist or consult with a witch will suffer the same fate. To put that into perspective, the family and friends of anyone dare not try to assist them out of fear that if their loved one was in due course found guilty, then they too would be deemed guilty by association and face execution.

Based on the Survey of Scottish Witchcraft Database, compiled by Edinburgh University, there were eighteen known accused witches in Perth, with a few others from the immediate surrounding area. It must, however, be noted that the records which remain

are not complete. Some Church records were lost in the aftermath of the Reformation and subsequent wars, while for many it was a case that the accused were apparently deemed not worthy to have their names recorded. You will find references in documents covering the trials which use terms such as 'some other witches', telling you others were involved, but without telling you how many or their names. As a result, while the Witchcraft Database is the most complete online resource to be able to search for accused either by town, name or year, others may have also been persecuted and prosecuted.

Using the Witchcraft Database and other resources, the following list in order of the year accused has been compiled:

20 December 1580: An unnamed witch was banished from the town.

12 February 1581: An unnamed witch is imprisoned for eight days.

11 April 1568: A relatively large trial occurred at this time, with James Kilgour from Perth being noted as being associated with a trial where Effie Roger, Cristeane Johnstoune, Jonet Curchan, James Chalmer, Catherine Campbell and Christeane Jak are listed as the accused. From the information available this was a fairly widespread trial with other accused involved; however, despite the numbers involved, the outcome does not appear to be documented.

The former City Chambers is built on the site of the old Tolbooth.

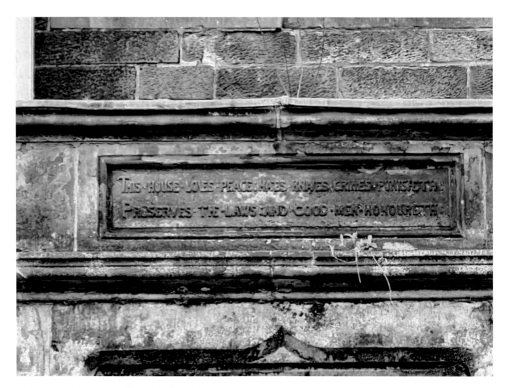

The plaque above the door for the old police station reads: 'This house loves peace, hates knaves, crimes punisheth, preserves the laws, and good men honoureth.' The same words were written on the wall of the former Tolbooth.

16 April 1582: It is recorded that an unnamed witch being held in the tolbooth be given 8 doits a day. This note is seen to give the false impression that the accused was being well treated, as a doit was a Dutch coin of very little value.

26th July 1588: John Myller and Marjorie Blackie were accused of bewitching and murdering William Robertsoun. The case was referred to be heard by the judiciary of Perth, yet no outcome is noted.

2 November 1589: The kirk session records that a woman named only a 'Guddal, spouse to Richard Watson' was accused of witchcraft by John Watson, presumably a relative of Richard. The basis of the allegation was that John could see it in her, and so others were also called to answer whether they too could see an evil within the woman. Under oath, they stated they did not and that she was a good woman who cared for her ill husband. The accusation was dismissed and instead a charge of slander was brought against John Watson and his daughter Helen.

1 December 1589: Violet Brown was accused of witchcraft and devilry against God's word. It was alleged that she had a young man at her house from whom she took a gold crown in exchange for turning the riddle with shears, an old form of fortune telling. She denied

all charges and a witness, John Hutton, was brought to give evidence. He confirmed that he was in the house and witnessed the young man come in and hand over the coin, but that Violet did not turn the riddle. No other information is noted.

23 November 1597: A request is sent by the magistrate for a commission to execute a witch named Janet Robertson, who was being held in custody.

3 March 1598: A complaint was made against Anges MaCaw or MaCawis which resulted in her facing trial for witchcraft. The information is very scant. It shows that two other

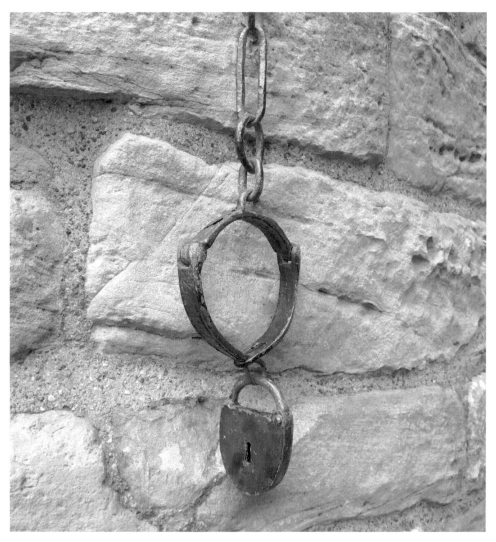

The 'jougs' were a method of torture where the victim was secured in an iron collar attached to the wall by a chain too short to allow sitting or lying. These were used to cause sleep deprivation. This particular example is in Abernethy, near Perth.

The South Inch, where those accused of witchcraft were executed and burned.

women, Elizabeth (Bessie) Ireland, from Perth, and Issobell Douglas, from Dunkeld, were also accused and that the accusation occurred due to a family dispute.

9 September 1598: Janet Robertson and Bessie Ireland, both mentioned earlier, along with Marion Macause were burnt on the South Inch as witches.

13 February 1601: David Roy was accused of consulting with a witch to obtain a potion to make his employers daughter fall in love with him. When this did not work, he forced himself upon her. Despite making a full confession, he was initially found innocent, but this decision was reversed by the Privy Council in May 1601. His fate is not noted, yet is it likely he would have faced execution.

22 December 1612: Janet Campbell was arrested and facing trial, although no other information other than she was held in Perth Tolbooth is available.

30 May 1615: The trial of Marion Murdoch started. No other information is available.

18 December 1620: The kirk session and the town council were to meet the following day to decide how to proceed with accusations made against James Stewart, who had been accused of witchcraft and charming. The outcome of the meeting is not noted.

15 May 1623: Issobell Haldane was arrested and interrogated by the session of Perth. Although no torture is recorded, it is almost certain she would have faced physical and mental abuse to secure the confession.

19 June 1623: Margaret Hormscleugh is noted as being brought into a trial. The notes make reference that Margaret was held at Perth Tolbooth for selling charms and that she was subsequently named by another woman who, in her confession, stated that it was Margaret she had consulted for advice about an illness. The trial of Issobell Haldane has the same commencement date and so it would appear that Issobell was the person who named Margaret. Supplementary information states that Margaret was accused of witchcraft against cows and a child, and so it is possible it was Issobell's child that had been sick. The outcome of the trial is not noted; however, the kirk sessions contain details of further cases soon after where women sought the assistance of witches to cure their ill children, and a footnote states that by the time of these trials the witches had already been executed. It therefore seems likely that Margaret and possibly Issobell had been sentenced to death.

26 April 1626: Bessie Wright from Scone is noted as being reported to the ministers of Perth on accusations of using witchcraft to heal ailments. Bessie may have first been brought to the attention of the authorities as early as 1611; however, the records have unfortunately been lost. Bessie is said to have admitted to having an ancient book that gave details of herbal remedies which had been passed down through her family. As she was not deemed to be under the influence of the Devil, nor doing his bidding, the authorities were left with some difficulties in pursuing a charge of witchcraft. Her case was referred to be heard by the Earl of Menteith, Lord Justice-General. She was imprisoned meantime, and no further information regarding her fate is held.

1715 (exact date unknown): Margaret Ogilvy is noted as being the wife of a soldier and being accused of witchcraft. Perhaps as a sign of the belief in witches waning by this time, she is noted as being banished from the town under threat of being strangled and burned should she return. In the same year (possibly the same time) Elizabeth, daughter of John Murray, and Sarah, widow of James Johnston, were also found guilty and banished on the same terms. However, it is stated that the civil magistrates held a retrial and, having found all three women guilty, they were executed and their bodies burned at the North Inch.

As can be seen from the above list, trials prior to the North Berwick Witch Trial of 1591 tended to be more lenient than those after, which demonstrates the effect of King James himself becoming involved.

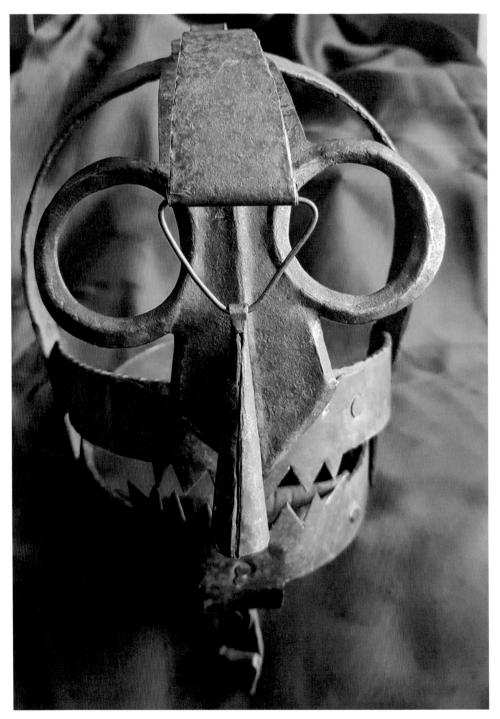

This device, known as a Scold's Bridle, was initially designed to punish and humiliate women who spoke too much. A metal spike within the bridle was inserted into the mouth and would pierce the tongue if you tried to talk. They were also used during the witch trials to prevent the accused from talking and to cause great discomfort.

The thumbscrews, or Pilliwinks as they were also known, were a basic but effective device that could be used to apply immense pressure on the thumbs and fingers, eventually crushing them if the victim could withstand the pain.

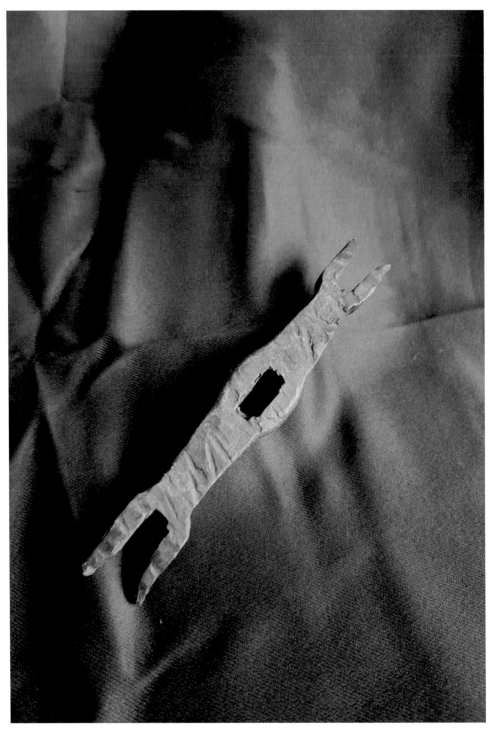

The Heretic's Fork was a double-pronged metal device, held below the chin and above the breastbone by a leather strap around the neck. This forced the victim to keep their head tilted backwards and prevented any sleep.

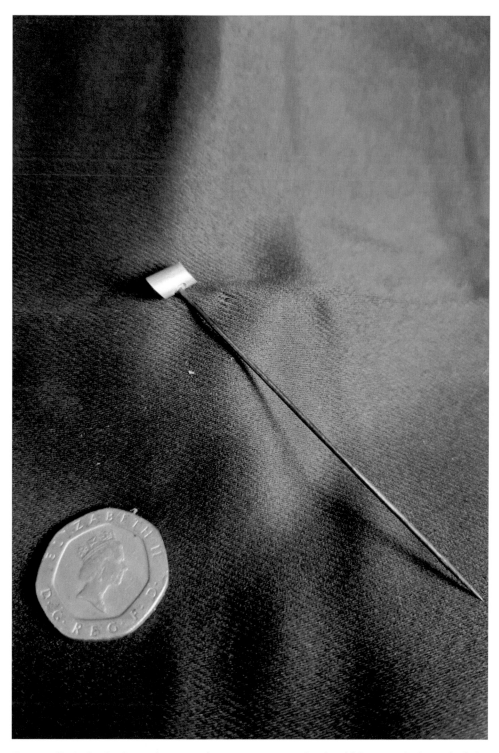

Pins not dissimilar in size to the one in the picture were used to 'prick' the victim's skin to look for the Devil's mark – a spot where it was believed they would not bleed or feel pain.

A simple stone marks when Janet Horne, the last person documented to have been burned as a witch, was executed. The stone only bears the year of her death, which is incorrect.

The area identified on old maps to show where those accused of witchcraft were burned is now used as the golf course. Hole 3 bears the name 'The Witches'.

In addition, it can be noted that in the mid- to late seventeenth century, the number of trials decreased. There were a few in Perth during this time, but the outcome for these is noted as there not being enough evidence and so the trial dismissed. The reason for the decrease during this time is twofold. Firstly, this was the time when Oliver Cromwell and his forces invaded much of Scotland. While there is much debate whether Cromwell supported the witch trials, it is fair to say that under his occupation the number of trials declined. Secondly, a change in the legal process brought local trials to an end and there was a move to have the cases heard in centralised courts. This reduced the power of the town authorities and required a higher level of proof of the crimes.

In Perth, as has already been mentioned in some of the trial notes, those accused of witchcraft were mainly held in the tolbooth. These buildings were common across Scotland and most commonly provided a debating chamber for the town council, a courtroom and a jail. The provisions within the jails were basic, if there were any at all, and those accused of witchcraft faced particularly harsh treatment, often being chained to the wall by a collar secured around their neck to ensure they could not sleep. This sleep deprivation was one of the key methods to obtain a confession as it made the accused disillusion and more likely to confess to the charges being put to them, although if that did not work far more brutal measures would be used. While many examples of tolbooths remain across Scotland, the one in Perth was demolished in 1839. It stood on the corner of High Street and Tay Street and was replaced by the town council administrative offices and police station.

Contrary to the belief many have, convicted witches were not normally burned alive. That is not to say it did not happen, when the records state an accused was 'burnt quick' it indicated they were burned alive. The common process of execution was strangulation with the use of a simple rope garrotte, sometimes fed through or around the stake on which the body was later burned. On other occasions the body was thrown into a fire or into a barrel of tar and set alight. Executions of these types commonly took place outside the town centres for a number of reasons, including superstition, the smell and to avoid the risk of buildings within the town accidentally catching fire. In Perth the executions took place on both the North and South inches. Records indicate that on the North Inch there was a small hollow with large stones around it which marked the burning site, which is shown on older maps with the words 'Witches Burnt Here, 1623'.

The Witchcraft Act was finally repealed in 1735, with the last known accused witch to be burned in Scotland being Janet Horne, who was executed in Dornoch in 1727. This would place the 1715 trial in Perth as being amongst the last trials in the country.

8. The Gowrie Conspiracy

One of the most curious incidents that occurred in Perth is now known as the Gowrie Conspiracy. It took place on 5 August 1600 and much remains a mystery to this day.

The events took place at Gowrie House in Perth, a grand home that was built in 1520 on behalf of the Countess of Huntly. After her death in 1526, it was purchased by Lord Ruthven. The three-storey house with extensive grounds sweeping down to the River Tay would have been one of the most prominent properties in Perth at this time; it would have been deemed to be fit for a king, which is perhaps why it was chosen. Those involved in the conspiracy were John and Alexander Ruthven, the sons of William Ruthven, the Earl of Gowrie, who was executed on the orders of King James in 1584 following the Raid of Ruthven and his later attempts to plot again against the king.

Falkland Palace was used as a royal hunting lodge for the Scottish monarchs, and it was here that King James had been staying. (Sarah Charlesworth, CC BY-SA 2.0)

The gate leading to the orchard and onto the deer hunting grounds at Falkland Palace. (M. J. Richardson, CC BY-SA 2.0)

On the fateful day, King James VI, who had been staying at Falkland Palace, had set out early in the morning to enjoy a day hunting deer. Accompanying him on the trip were a number of nobles, including his most trusted advisors, the Duke of Lennox and the Earl of Mar. Their hunt was interrupted by Alexander Ruthven, who approached on horseback insisting that he needed to speak with the king on a most urgent matter. He was allowed to do so and he explained that both he and his brother were detaining a man at Gowrie House in nearby Perth. It is not a matter that would normally warrant disturbing the king, but he advised that it was a foreign gentleman who was carrying a significant amount of money with him. They could not ascertain what the money was for and felt it would be of benefit for the king to meet with the man to try to find out what his intentions were.

Whether simple curiosity or concern that there may be some further plot being hatched against either himself or another significant figure, the king agreed to travel to Perth after he finished his hunting trip. Alexander Ruthven told the king that they did not want to draw attention to the fact the man was being held out of fear that if word got out regarding the sum of money he was carrying the property may be subject to attack either by desperate locals or anyone connected to the man they were holding attempting to free him. For this reason, he asked that the king arrive in secrecy with a minimal number of guards with him. By this time, the alarm bells should have been ringing in the king's head.

Upon arriving at Gowrie House in the early afternoon, accompanied by only a small number of aides, he was met by John Ruthven. Rather than there being any urgency in taking the king to meet with the stranger, John insisted that they had a meal prepared for them so all could dine first. After all had eaten, Alexander offered to take the king to see the man they were holding but insisted that it was only the king who accompanied him. He led James through a number of interconnecting rooms, which had locked doors between them, and he relocked the doors behind them as they went saying it was to prevent any risk of the man escaping. Eventually they ended up in a room high up in the tower, up a narrow staircase and found a man standing there. Any relief that the king may have had would have been short-lived as, instead of a bag of gold coin, the man had a dagger, which Alexander seized and held towards the king, threatening to kill him if he cried out or attempted to open any of the windows to draw attention.

The Sheriff Court stands, in part, on the site of Gowrie House.

A drawing of Gowrie House by an unknown artist from *The Book of Days* by Robert Chambers (1870).

He then departed, leaving the two men alone in the tower room, locking the door behind him. James enquired as to the identity of the man he was imprisoned with and he explained that he was named Henderson and was one of the Earl of Gowrie's servants. He had no knowledge of any stranger being held within the property or even what he himself was to do. He was simply ordered to with in that room with his dagger, which he had done.

Meanwhile Alexander had returned to where the king's entourage waited and set about convincing them that James had seen the stranger and had left the property to make his way back to Falkland. No doubt his men had conflicted thoughts at this; it would seem strange for James to leave without them, yet they knew that if he had they would be expected to catch up with him for his own security. They went outside to gather their horses while Alexander Ruthven retuned to the tower room in which King James was being held. James has seen his men outside and fought with Ruthven when he returned, shouting 'treason!' as loudly as he could. As he hoped, this caught the attention of his attendants, who saw the two men struggle and rushed to help their king.

What followed is unclear, yet it is said that one of the king's men, John Ramsay, discovered a hidden doorway and staircase which led to the tower room. He challenged Alexander who was stabbed in the fight that followed and was pushed down the stairs, where he was killed by Thomas Erskine and Dr Hugh Herries. James Ruthven, upon

realising his brother was dead, rushed up to the king's room where he too was killed. No one else was hurt.

While the king and the government put out the claims that this had been an attempted kidnap which James was lucky to have escaped from with his life, many had their suspicions about the whole incident. There were so many areas where either the king or his aides should have realised the potential threat, and the story seemed so far-fetched in some areas that they suspected something else was at play. The king acted angrily and defensively to any suggestion that this had been anything other than another attempt on his life, raising further suspicions. Rumours started that this had been a revenge attack on the Ruthven family in return for the failed attempts against the king during and after the Raid of Ruthven. It was further suggested that the king was in debt to the Ruthvens, and that the whole story had been fabricated to conceal what was in fact the murder of the brothers, ending the family blood line, eradicating the debt and creating a position whereby the crown could take possession of their property.

DID YOU KNOW?
In what could only be seen by most as a peculiar and somewhat morbid act, the bodies of the Ruthven brothers faced trial for treason and, unsurprisingly, were found guilty. The corpses were then hung, drawn and quartered, as this was the punishment for treason. The reason for this action is thought to be that the conviction of treason resulted in the estates of the accused to be forfeited to the crown.

DID YOU KNOW?
In 1651, King Charles II stayed at Gowrie House after his coronation in Scone. Similarities cannot be avoided with the Gowrie conspiracy as the king's movements were severely restricted and he was virtually detained within the constraints of the house itself. After the Restoration, he later returned in 1663 and was entertained at the house.

9. Oliver Cromwell in Perth

Oliver Cromwell is, undoubtedly, a significant figure in British history who evokes thoughts of war and destruction. Yet some scholars argue that he was in fact a key figure in bringing peace to the country under the control of his New Model Army, with the need for peace being one of the factors stated in his first speech to Parliament. While it is true that many areas that fell under his control saw considerable investment in the rebuilding of the infrastructure, including defences, it was the methods used to attain control which led to his reputation as a warlord.

Before exploring the impact of Oliver Cromwell in Perth, it would seem pertinent to briefly discuss just how powerful he was, and how he rose to this position, to put his importance into perspective.

The death of Queen Elizabeth I in 1603 without an heir led to the crown passing to King James VI of Scotland – her cousin. This peaceful union of the kingdoms through family ties made James the leader of England, Scotland and Ireland. However, the unification faced challenges, notably differing religious practices and resistance from English nobles. King James' reign was marked by opposition, including the famous Gunpowder Plot and resistance from the English Parliament.

King James' son, Charles I, succeeded him in 1625, recognizing the importance of religious conformity. His efforts, however, led to conflicts with the Scottish Church and English Parliament. In 1629, Charles dissolved the English Parliament, weakening his authority. The rise of the Covenanters in Scotland, opposing his religious interference, led to the First Bishops' War in 1639. Charles' campaign ended in a truce but left him humiliated.

Charles' subsequent request for Parliament's support for a full-scale attack on the Covenanters was denied. The Covenanters then invaded England, capturing Newcastle and forcing Charles to concede. The English Parliament, frustrated with Charles' focus on Scottish issues, collaborated with Scottish nobles against him. In 1646, Charles surrendered to a combined English-Scottish army and was later executed.

During this period, the English Parliament formed the New Model Army, differing from traditional forces by forming regional regiments which could be called to action quickly whenever needed. Politician and soldier Oliver Cromwell had opposed further negotiations with Charles, leading to the king's trial and execution. Cromwell then declared England a republic and when Scotland formally recognised Charles II as king he reacted to this act of defiance with force, marching his New Model Army north.

Cromwell's campaign for Scotland started in July 1650, and after an unconvincing start, he was victorious at the battle of Dunbar in September 1650, his momentum built. The Scots forces were led by Sir David Lesley, Lord Newark, and they seemed on all

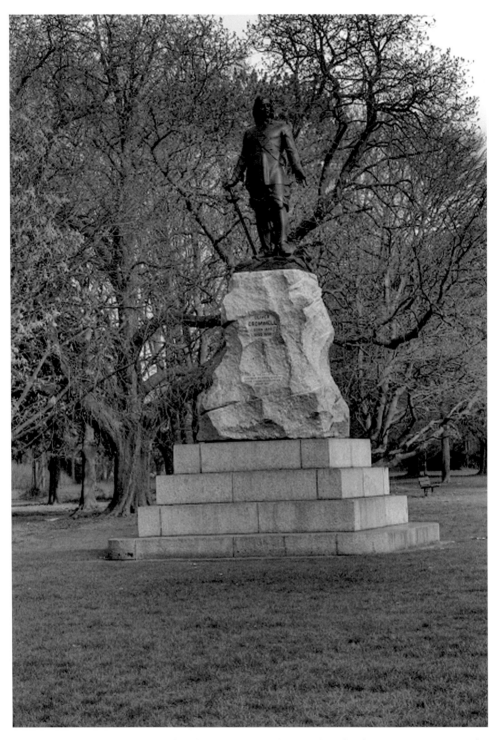

Statue of Oliver Cromwell in Wythenshawe Park, Manchester. There has been controversy over the statue since it was first erected in 1875 close to the city's cathedral. It was relocated to the park in the 1980s. (David Dixon, CC BY-SA 2.0)

accounts to have the upper hand, he vastly outnumbered Cromwell in troop numbers and was well organised, but a concentrated attack by Cromwell resulted in disrupting the formation of the Scots army, leaving between 800 and 3,000 Scots dead, and up to 10,000 taken prisoner. Cromwell advanced to Edinburgh, taking control of the city but not the castle.

Meanwhile, Lord Newark had escaped to Stirling, where he had re-gathered his troops and had called upon the Highland chiefs. As had happened in Scotland since its early origins, the clans were prepared to put aside any differences and come together against the common enemy. Even nobles who had not been supporters of Charles, began to support the Royalist cause as the better option that succumbing to Cromwell's rule.

Cromwell faced difficulty in his march north. The only road suitable to move military forces from southern Scotland to the north was that which crossed Stirling Bridge, yet Stirling had remained defiantly outside of his grasp. His army was already stretched and Edinburgh Castle remained out of his control. He needed to retain sufficient troops to hold the ground he had successfully taken and as a result, despite attempts, he could not launch an all-out attack on Stirling.

Although it could be seen an ambitious plan, Cromwell looked at alternative methods to cross the River Estuary. A number of specially designed flat-bottomed boats were constructed to transport large numbers of troops across the Forth, and on 17 July 1651, the 1,600 troops successfully crossed.

Memorial cairn to commemorate the Battle of Inverkeithing. (Euan Nelson, CC BY-SA 2.0)

Over the following two days a further 2,500 men made the crossing. Cromwell's intention was to cut the supply lines of both provisions and reinforcements from Fife and Perth to Stirling, forcing Lord Newark to surrender. Realising the risk, the Royalist forces attacked but were ultimately defeated.

Cromwell now had control of the lands to both the north and south of the River Forth, allowing him to use larger ships to transport the bulk of his army over to Fife. Cromwell himself then took part of his forces to Perth, which remained a main Royalist base, to take it so that Stirling could be starved of supplies.

The forces of Oliver Cromwell reached Perth in August 1651. The city at that time remained protected by walls on three sides, with the final side being protected by the river. Although almost nothing remains of the city walls today, they are believed to have stood roughly up from the Tay in the vicinity of Canal Street, along the position of South Methven Street and then back to the Tay around Mill Street. These walls were in turn surrounded by a ditch which was filled by water flowing in from a subsidiary water course from the River Almond, making them difficult to attack.

Although some writings from the nineteenth century suggest that during a two-day siege Perth suffered an attack from the cannons brought by Cromwell, and that both sides had lost several soldiers, the more common report is that it was largely a peaceful surrender. The order had been given to run horses and carts through the streets of Perth, and that drums should be beat loudly from all around to create the impression that there was an army amassing behind the walls to defend against any attack. Whether influenced by this or not, Cromwell prepared terms for the surrender of the city which were taken to the authorities within Perth to consider. They promptly agreed to the conditions laid out by their opposer and the gates were opened, allowing him to enter with no attack or loss of life.

Once inside, Cromwell was received by the town provost, Andrew Grant, and escorted along with his officers to the home of Lieutenant John Davidson. Unknown to Cromwell at the time, his army had been watched since his arrival in Fife by a small group of around 100 men, with Davidson being one of the officers, to assist the fight against Cromwell in Fife as well as to provide information on the advancing enemy forces back to Perth. It was also Davidson who had ordered the carts to be driven throughout the town and the beating of the drums in an attempt to distract them. It was perhaps information fed back by these spies which made both Lieutenant Davidson and Provost Grant realise that trying to hold out should Cromwell attack would be pointless, hence accepting the terms of surrender rather than try to defend the town.

It is said that during this first meeting Cromwell began to realise just how ill prepared Perth was in the event of an attack and he asked the men how they had intended to defend the town against his army. The provost reputedly replied that they had no intention of defending the town in the event of an attack. All they intended to do was delay Cromwell long enough to allow King Charles and how forces leave Stirling and make it into England where they were advancing to launch an attack.

The South Inch, where Cromwell's Citadel stood.

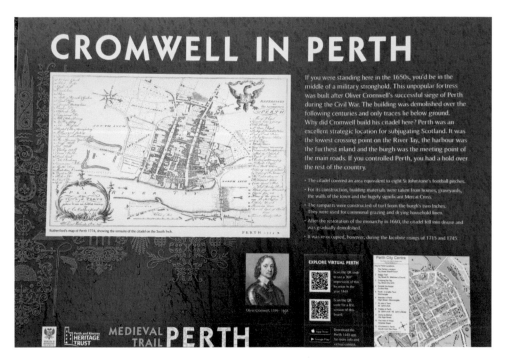

This information board can be found in the car park on the South Inch. It details and illustrates the areas occupied by Cromwell and his men, along with providing a depiction of the sheer size of the Citadel.

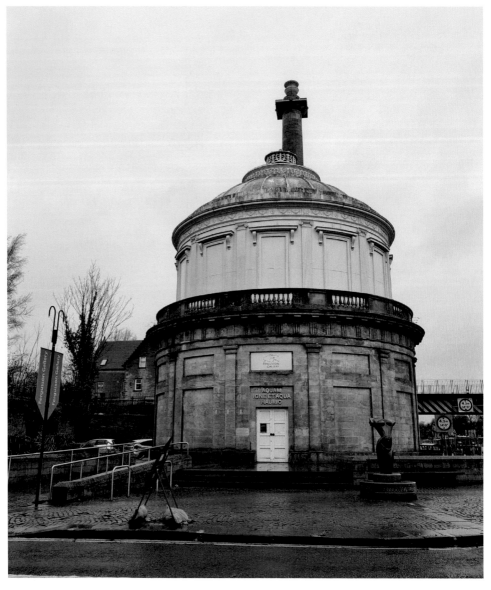

The former waterworks building, most recently the Fergusson Gallery, once bore a plaque stating that it was built of the site of Cromwell's Citadel.

DID YOU KNOW?
Shortly after the meeting between Oliver Cromwell, Provost Grant and Lieutenant Davidson the wall of Davidson's house, where the meeting took place, collapsed. He is said to have been heard saying he wished it had fallen sooner, as it would have crushed Cromwell beneath it.

While nothing remains of the Citadel in Perth, a remnant survives of the Citadel in Ayr which gives an impression of the grandeur. (Thomas Nugent, CC BY-SA 2.0)

The site of Perth Grammar School. The large plaque on the front of the building tells that the school stood on the site prior to being demolished by Cromwell's forces. (Chris Downer, CC BY-SA 2.0)

Site of the Mercat Cross. The original medieval Mercat Cross was demolished by Cromwell's forces. Although it was replaced, it was again subsequently demolished. A monument dedicated to King Edward VII now stands on the site. (David Dixon, CC BY-SA 2.0)

The original Perth Mercat Cross now stands at Fingask Castle, between Perth and Dundee. An inscription at the base once read: 'Pillar of the Old Market Cross of Perth pulled down by Cromwell's army in 1651 and rebuilt in 1699 and finally taken down in 1763.' (Kim Traynor, CC BY-SA 2.0)

Cromwell was understandably enraged at this. He knew the king was in Stirling and had heard rumours that he was taking advantage of the bulk of Cromwell's army being to the east and north-east of Stirling which left the route south to England largely undefended. The tactics used in Perth had delayed him by around a day, which in turn gave King Charles the opportunity he needed. He made his displeasure known in no uncertain terms to Provost Grant and threatened to have Lieutenant Davidson hung for his actions, yet ultimately decided to spare both of them. All was not lost for Cromwell, as he had already divided his forces and sent some to Stirling prior to his advancement on Perth. With this confirmation of the king's movements, he did, however, send additional troops towards Stirling.

When Cromwell departed the town the following day, he left regiments of both foot soldiers and dragoons to retain control of Perth. Unsurprisingly, the people of the town did not welcome their occupiers. Not only did they have the command of the town, but food, drink and accommodation also had to be provided for an estimated 200 men. But worse was to follow. Any hopes that the surrender of the town would avoid its destruction were dashed when the construction for a mighty citadel were put into place. This massive defensive fortress was built parallel to Greyfriars Burial Ground and extended across

into the vicinity of the South Inch. It was one of five that Cromwell had constructed in Scotland, and a sign of the importance he placed on Perth.

The construction, however, required material, and that was sourced from within the town. In total it is believed that around 140 houses, the hospital, grammar school, the Mercat Cross, malt barns and pillars from the bridge were demolished to provide stone for the Citadel. In addition, the stone from the walls around Greyfriars Burial Ground was used, along with up to 300 tombstones. Kilns were destroyed and cobbles taken from throughout the town along with earth dug from the surrounding area to form embankments at the loss of valuable grassland, which raised around 200 merks a year for the town. Boats were taken to provide timber and a moat, fed by the River Tay, was dug around the new fort. The residents who found themselves homeless or who lost their income as a result were left to seek alternative accommodation and employment within the town, resulting in overcrowding and great hardship.

The resulting building was square in shape, with each side measuring approximately 260 feet (around 80 meters) with a bastion on each corner. Inside, sufficient accommodation for the English soldiers was provided, and in addition there was sufficient stabling to house around 200 horses. A pier was also constructed allowing for the easy loading and unloading of boats on the River Tay.

Cromwell's forces, under the command of General Monck, remained in charge of Perth until his death in 1658.

After the restoration of King Charles II, the town council of Perth gifted him Gowrie House and all its land in the town as a sign of their devotion to him. In 1661, King Charles issued a charter gifting the Citadel and all that remained within it to the council in return for their servitude and to compensate for the losses imposed on the town under the control of Cromwell. Sir George Kinnaird of Rossie was tasked with the responsibility to dismantle the building while the guns and canon that remained inside were sold. The town treasurer purchased much of the stone which it in turn resold, which gave a much-needed boost to the town's finances.

In a bitter twist of fate, any hopes that the townsfolk held that they would soon see improvements once again after their suffering over the previous years were soon dashed. The king's exchequer considered that they could not afford to simply give away the Citadel and communication was sent to the town stating that the sum of £366 16s 4d be paid as a nominal value of the Citadel. When the town authorities appealed this the response was short and swift. They were advised if they did not pay the compensation already requested for the Citadel immediately, then it would be increased.

DID YOU KNOW?
Although no visible sign of Cromwell's Citadel in Perth remains today, it is a Scheduled Monument. This is in part due to the site being largely undisturbed, meaning there is a high potential for findings under any future archaeological exploration.

10. The Jacobites

Many people across Scotland and the wider UK will have heard the stories of the Jacobites and their military conquests before their final defeat by the government forces at the Battle of Culloden in 1746. Before looking at their role in the history of Perth, it is probably worthwhile briefly exploring who the Jacobites were and what they were fighting for.

The term 'Jacobite' originates from the Latin word 'Jacobus' meaning James, and so in basic terms the Jacobites were supporters of James, in this case King James VII of Scotland and II of England and Ireland. Prior to succeeding to the throne, James had converted to the Catholic Church in the late 1660s, which caused issues with his brother, King Charles II. His faith became public knowledge in 1673, when the Test Act was introduced. This required anyone holding positions in public office to swear an oath to the king and the Protestant English Church while denouncing the Catholic faith. Rather than do so, James resigned from office. An exemption was made to allow him to continue to sit in the House of Lords, but suspicions deepened when he married Mary of Modena, a Roman Catholic. Rumours followed of a Catholic plot to kill Charles and place James on the throne in his place, leading to successive failed attempts in Parliament to create a statute which would prevent James from succeeding his brother.

DID YOU KNOW?
The fort built by Oliver Cromwell on the North Inch was utilised by the Jacobites during the 1715 and 1745 uprisings.

Despite his faith, James was supportive of the Anglican Church and had agreed for his daughter, Mary, to be raised as a Protestant. He later consented to her marriage to William of Orange, who was also a Protestant. However, when he became king in 1685, a number of rebellions against him seem to have caused James to take a much less tolerant line. He began to use his authority to excuse individuals for the Test Act, appointing those who followed the Catholic faith to positions of power and gave new military forces to Catholic commanders. When Mary then became pregnant, the fear of a new line of Catholic monarchs became too much, and Protestant leaders began discussions with the king's son-in-law, William of Orange, to take action. In 1688, the Archbishop of Canterbury submitted a request to the king to withdraw legislation he had introduced, known as the Declaration for Liberty of Conscience. This allowed new freedoms for those who followed

what were deemed minority faiths, including Catholicism. James sought to prosecute the bishops who wrote the petition but they were later acquitted, following which the king's opponents invited William of Orange to send an army to free Parliament.

With the Protestant military leaders supporting the invading forces of William, King James had no choice but to flee. He was captured, but later allowed to continue to France, following which William, and his wife Mary, were crowned joint rulers in England, a move which was followed by the Scottish parliament. This was not popular, particularly within the Highlands, where many still considered the Stuart monarchy to be the true rulers of the country.

The first Jacobite uprising started before William and Mary even had the opportunity to establish themselves. John Graham, 1st Viscount of Dundee, raised an army in the Highlands and, accompanied with a small number of Irish soldiers, marched south. The government quickly put together an army to counter the advancing troops, led by General MacKay. Perth was supportive of the Jacobite cause and the city was relatively poorly defended, and so if the Viscount of Dundee reached Perth he would be able to unite with other supporters from the lowlands, defend Perth and advance on the key city of Stirling.

The opposing sides met north of Perth at Killiekrankie on 27 July 1689. Any hopes that the government had to prevent the Jacobites from advancing were swiftly dashed, with the battle, which lasted less than one hour, being a decisive victory for the Jacobites.

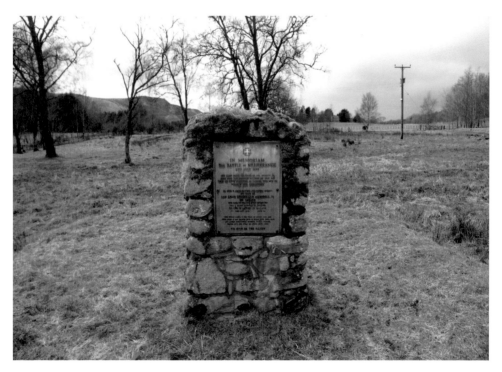

The memorial for the battle. While the memorial suggests it also marks the burial place for the commanders of both sides of the battle, there is no archaeological evidence to support this.

The Soldier's Leap. A daring escape made by one of the Redcoat soldiers is now noted due to the incredible leap made across the river, indicating the desperation to escape at any cost. (Anne Burgess, CC BY-SA 2.0)

Dunkeld Cathedral, where the government forces established a defensive stronghold from which they could attack the Jacobite army.

Dean's House, also known as Old Rectory House, is one of only three houses that survived the fire of 1689 and is the only one that remains today. (James Denham, CC BY-SA 2.0)

Despite the win, the battle would be the beginning of the end of the uprising. Viscount Dundee was fatally injured, leaving his army under the command of colonels with less experience.

In response to the defeat, the government sent new forces to meet the Jacobites. The town of Dunkeld, around 20 miles north of Perth, was seen as vital. If it was to fall under the control of the Jacobites it would provide a clear route and supply chain to Perth. Dunkeld was not protected by a defensive wall, so when the government army arrived on 17 August they were able to take the town with relative ease, but had to use the cathedral as defensive stronghold. When the Jacobites attacked, it was quite unlike anything that had been seen before. While their initial charge on the town, the type of battle the Highlanders were familiar with, was successful in forcing their opponents back, once the fighting moved to the narrow streets of the town, both sides were in unfamiliar territory. The Jacobite forces began to use houses for defences from which they could fire their muskets. This was, however, an error of judgement. The government troops were able to set the houses alight, and with their close proximity to each other, timber construction and thatched roofs, the fire spread quickly, killing many of the Jacobites who had taken refuge within. After sixteen hours of exhaustive fighting, and with ammunition running low, the Jacobites began to withdraw, many fleeing back to Perth where they could blend back in with the town's society to avoid detection.

The next Jacobite uprising was not until 1715, by which time James VII and II had died and had been succeeded by his son, James Francis Edward Stuart, who would later become known as the Old Pretender. Much had changed since the earlier uprising. The Act of Settlement had been passed, which ruled that should both William III and his sister-in-law, Princess Anne pass without children, then the crown would pass to the granddaughter of James I, Sophia of Hanover, rather than to those with a stronger claim yet who followed the Catholic faith. The kingdoms of Scotland and England not only had a shared monarch, but the Act of the Union 1707 now joined the two countries under the name Great Britain and formed a parliamentary union. In 1714, Queen Anne passed without a direct heir and, in accordance with the Act of Settlement, the crown should have been passed to Sophia of Hanover, but as she had also passed it instead went to her son, George I.

It was this which reignited the claims that the Stuart monarchy should be restored under James Stuart, who King Louis XIV of France had already formally recognised as the King of Scotland.

The Act of the Union had also caused much tension within Scotland, and by 1714 many of those who had initially been supportive had sufficient concerns that they were willing to consider supporting the restoration of the Stuarts. In August 1715, at James Stuart's request, the Earl of Mar met with clan leaders. An alliance was formed across the Highlands and the Lowlands, and Mar formally proclaimed James Stuart as the King of Scotland on 6 September of the same year.

His forces moved quickly to seize Perth, taking control of the city on 14 September. Here he was able to grow his forces considerably. Despite his army being far greater in number than those of the government holding Stirling, Mar delayed any attack and

View looking down over the battle site at Sherrifmuir.

waited in Perth for reinforcements to arrive and for planned Jacobite uprisings to start south of the border. However, these delays allowed the government time to prepare.

In November, Mar led the Jacobite army south, meeting with government forces led by the Duke of Argyll at Sheriffmuir. It was an indecisive battle with neither side being able to rightfully claim victory.

At the same time, despite initial advances by joint Scots and English Jacobites at the Battle of Preston, they were forced to eventually surrender as government forces continued to arrive. Support for the cause began to lose momentum and by the time James III arrived in Scotland and met with the Earl of Mar in Perth in January 1716, what could have been his momentous return was already effectively over. Without the hoped financial support from France, James struggled to reinvigorate the campaign and just over three weeks after his arrival in the city, both James and the Earl of Mar left Perth for a waiting ship to take them to France.

The final Jacobite uprising took place in 1745, when Charles Edward Stuart, elder son of James, arrived on the island of Eriskay on the west coast of Scotland. He only had a small army with him, yet what he lacked in forces he made up for with charisma. He also brought money and weapons. His unexpected arrival was initially met with little support amongst the Jacobites who, having already witnessed the consequences of the previous uprisings, were reluctant to once again go against the government forces without any major support from others, such as France. Charles however used his charm and assurances that if the

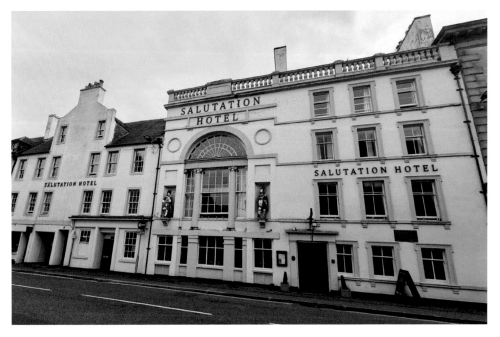

The Salutation Hotel in Perth. Although it is debated whether Bonnie Prince Charlie ever slept here, he did use a room (now named the Stuart Room after him) to meet and plan for the invasion of England.

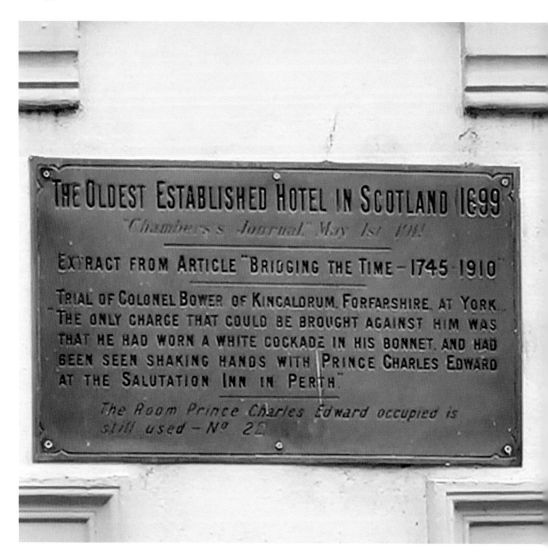

The sign on the outside of the Salutation Hotel commemorating the connection to Bonnie Prince Charlie.

uprising brought major success, then France would join the cause. He eventually began to win support and gathered an army of between 2,000 and 3,000 soldiers.

Charles marched south, all the while gaining new support, arriving in Perth in September 1745. Here he met with James Drummond, Duke of Perth, who had gathered around 200 troops from Crieff and the surrounding area, and Lord George Murray, an experienced military leader who had fought for the Jacobites during the 1715 uprising. Charles showed his gratitude by granting both joint positions as commanders within his Jacobite army. While many dismissed the Duke of Perth due to his lack of military experience, Lord George was altogether different and said to be a difficult man to get along with. As a result, the relationship between the two men was strained throughout.

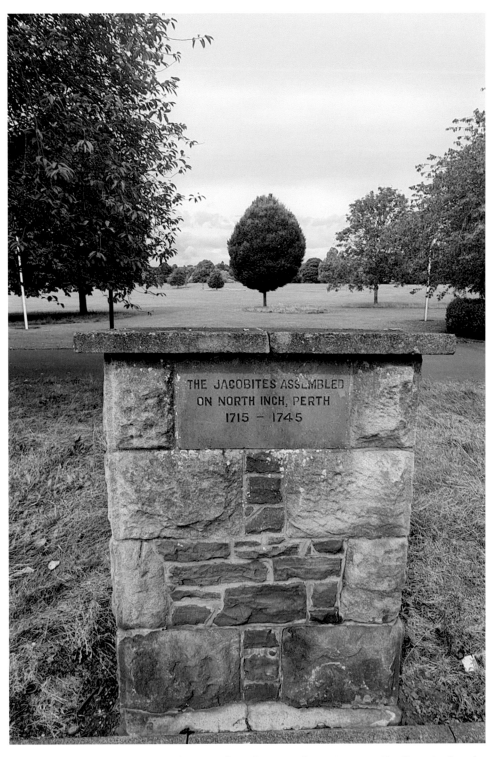

The Jacobite memorial, indicating the area where the army of Bonnie Prince Charlie trained on the North Inch.

The prince stayed in Perth for around a week, during which time he had his army perform military drills on the North Inch. He also demanded funds from the towns along the Tay to help support his military action, with it being said he requested £500 from Perth itself. While at Perth, he also proclaimed his father, James VIII, to be King of Scotland. It was also from Perth where movements against Edinburgh and the campaign into England were launched, and the city remained important both for raising funds and as a centre for supporters to meet and join the forces of Charles.

Charles took his army deep into England, where a major decision had to be made: whether to march on London. It was said to have been Lord George who persuaded Charles to instead return to Scotland, which he did, pursued by the government forces all the way by the Duke of Cumberland, who was delayed himself in Perth for a short while due to difficulties in gaining supplies.

The Jacobite and government forces met for a final time on 16 April 1746 at Drumossie Moor, near Culloden. Starving, exhausted, outnumbered and outgunned, the Jacobites stood little chance, yet fought on valiantly for their beliefs. It took less than an hour for the government troops to take the victory, with Bonnie Prince Charlie making his escape and returning to France.

DID YOU KNOW?
Following the Jacobite uprising in 1745, Gowrie House was given to the Duke of Cumberland who in turn sold it to the government. It was used as barracks and an artillery headquarters until it was demolished in 1806.

11. Modern Perth

As more peaceful times swept across Scotland and the United Kingdom as a whole, Perth, like many other towns and cities across the country, was able to re-establish itself.

During the eighteenth century the city became an industrial centre for linen, leather products and whisky, along with the production of beer and flour. Perhaps unexpectedly, given the silting of the river, ship building also became a growing industry, with timber being felled from the dense woodlands to the north and floated down the River Tay to Perth, where a number of smaller shipyards had become established.

The Lower City Mills. It is believed a mill has stood on this site since the twelfth century. The last use of the current building was the production of oatmeal, which stopped in 1953, with the building closing in 1966.

The Mercure Hotel is a converted water mill repurposed as a hotel, restaurant and events venue.

Stanley Mills, just north of Perth, was built to produce cotton on a large scale in 1786 and operated until 1989.

General view of Perth Port. (Paul McIlroy, CC BY-SA 2.0)

A large cargo of timber arriving at Perth from Sweden. (David Mersh, CC BY-SA 2.0)

DID YOU KNOW?
After losing its city status in 1975 due to local government boundary changes, Perth was once again reinstated as a city in 2012.

Although many ship builders were focused on smaller sailing ships, some were of a grander scale. The *Yorkshire Gazette* published an article on 21 April 1821, detailing the safe arrival of the first of two steam yachts at Leith. The yacht, built by James Brown of Perth and launched from the city, was said to have been the first steam vessel built on the east coast, and to be the largest owned in Scotland. In 1836, an iron steamship named *The Eagle* was constructed by the Perth Foundry two years before iron construction arrived in the better known and more established ports of Dundee.

By 1830, ship building was officially established as an industry within the city, and with there also being strong export and import links already in place, plans for the new harbour were originally prepared in 1833; however, delays to the start of work and rising costs resulted in a reduction in the size of the quays. The construction was scheduled to be finished in 1854, yet bankruptcy brought work to a halt once again.

Meanwhile, works to deepen the channel into Perth were completed by 1841, allowing larger vessels access. The harbour site was subsequently taken over by the council and works eventually completed.

DID YOU KNOW?
After the bridge over the Tay was destroyed by the river in 1648, Perth was reliant on a ferry crossing until the new bridge was opened in 1771.

Along with the development of the harbour, the railway also came to Perth during the nineteenth century, with a rail connection being established between Dundee and Perth in the 1840s. Consideration had also been made at the same time for a railway route to Inverness; however, it was considered that the terrain was too hilly for a line to be laid from Perth, so the alternative route from Aberdeen was decided upon. Construction was difficult, with different sections being built separately, and once it was completed it was considered to be a long route to have to travel from Dundee to Aberdeen and then across to Inverness. In the 1860s, a junction at Forres was constructed on the Aberdeen to Inverness line, which eventually made a connection with Perth, and in the 1890s a route between Aviemore and Inverness was added, giving a more direct link.

While the railway brought great benefits to Perth, both for transportation of goods and people, it was also a major factor in Perth never being able to establish trading routes with North America as the reliance on river craft to move goods around the country diminished. Tourism did, however, gain a boost, with the main transport links to Inverness and the Highlands being through the city, resulting in it becoming known as the 'Gateway to the Highlands'.

Tourism remains a significant part of Perth's economy today, along with agriculture, the service industry, renewable energy and the financial sectors. The port also remains an important part of Perth, with trade across Europe and Scandinavia as well as within the UK itself.

It is perhaps this combination of the rich heritage, riverside walks and parks and good economy that resulted in the online property retailer Rightmove ranking Perth the happiest place to live in Scotland in their 2020 survey.

DID YOU KNOW?
Sufficient evidence exists to show Perth had three harbours over the centuries. The earliest is believed to have been situated around the City Chambers, the second being alongside Greyfriars Burial Ground and the latest being at Friarton.

The platforms of Perth railway station. (Mark Nightingale, CC BY-SA 2.0)

Perth Railway Bridge. Until the construction of the bridge passengers from Dundee had to disembark and cross the Tay by ferry. This bridge, built in 1863 to replace an earlier timber bridge, was originally designed to swing open to allow larger vessels to pass on the Tay. (David Dixon, CC BY-SA 2.0)

About the Author

Gregor was born and raised in the town of St Andrews in Fife. Having been surrounded with history from a young age, his desire to learn about the past was spiked through his grandfather, a master of gold leaf work whose expertise saw him working on some of the most prestigious buildings in the country, including Falkland Palace. After talking to other staff in these monuments, he would come back and recall the stories to Gregor, normally with a ghost tale thrown in for good measure.

Growing up, Gregor would read as many books as he could get his hands on about ghost lore. Going into adulthood his interest continued, and he would visit many of the historic locations he had read about. After taking up paranormal investigation as a hobby, Gregor started to become frustrated at the lack of information available behind the reputed haunting. He has always felt it is easy to tell a ghost story, but it is not so easy to uncover exactly what happened and when, nor discover the people who were involved, that might lead to an alleged haunting. He made it a personal goal to research tales by searching the historical records to try to find the earliest possible accounts of events, along with the first telling of the ghost story – before it was adjusted as it was handed down from generation to generation. This proved to be an interesting area to research, and Gregor found himself with a lot of material and new theories about what causes a site to be allegedly haunted.

After having several successful books published about the paranormal, Gregor found himself uncovering numerous forgotten or hidden tales from history. These were not ghost related but were stories too good to remain lost in the archives, and he looked to bring these tales together to tell the lesser-known history of towns and cities, including often the darker past. He also has had a long-term interest in the Scottish witch trials and has collated extensive information from his research. This allowed Gregor to write his first book in Amberley's 'Secret' series, *Secret St Andrews*, which was followed by *Secret Inverness*, *Secret Dunfermline*, *Secret Dundee* and *Secret Stirling*.